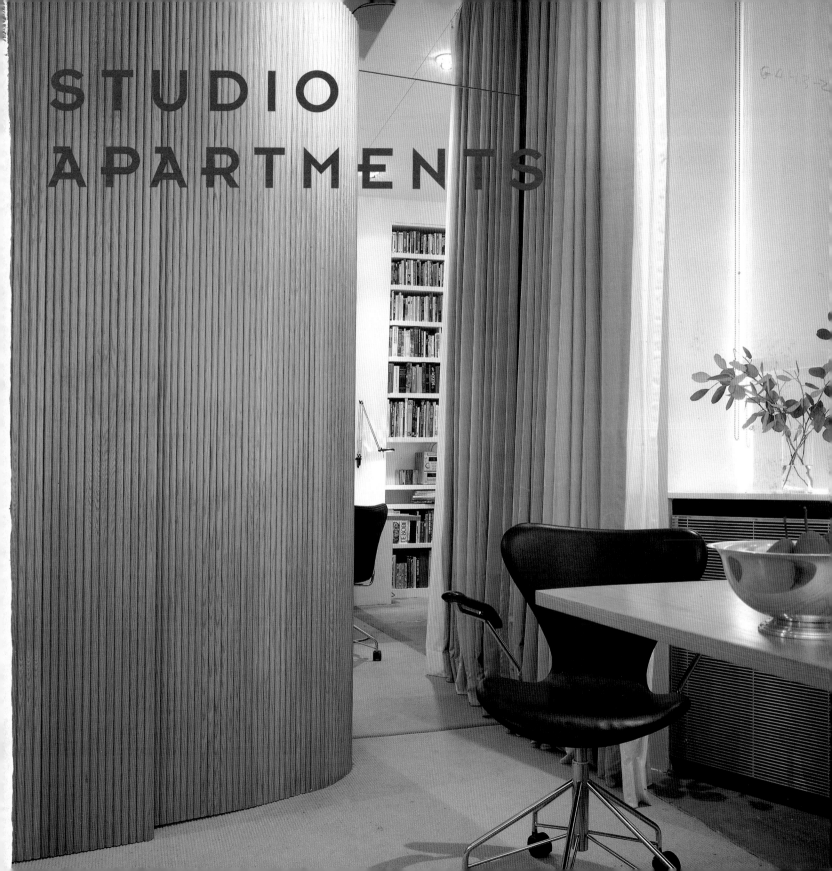

STUDIO
APARTMENTS

AN **HBJ** BOOK
WILLIAM MORROW AND COMPANY, INC.
NEW YORK

STUDIO APARTMENTS

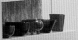

BY JAMES GRAYSON TRULOVE
IL KIM

Half-Title Page Photograph: Catherine Bogert

Title Page Photograph: Paul Warchol

Library of Congress Cataloging-in-Publication Data

Studio apartments: big ideas for small

spaces/by James Grayson Trulove and Il Kim.

 p.cm.

 ISBN 0-688-16829-9

 1. Apartments. 2. Interior decoration

I. Kim, Il, 1965-. II. Title.

NK2195.A6T78 2000 99-33604

747'.88314--dc21 CIP

Manufactured in China

First Printing, 2000

1 2 3 4 5 6 7 8 9/03 02 01 00

www.williammorrow.com

CONTENTS

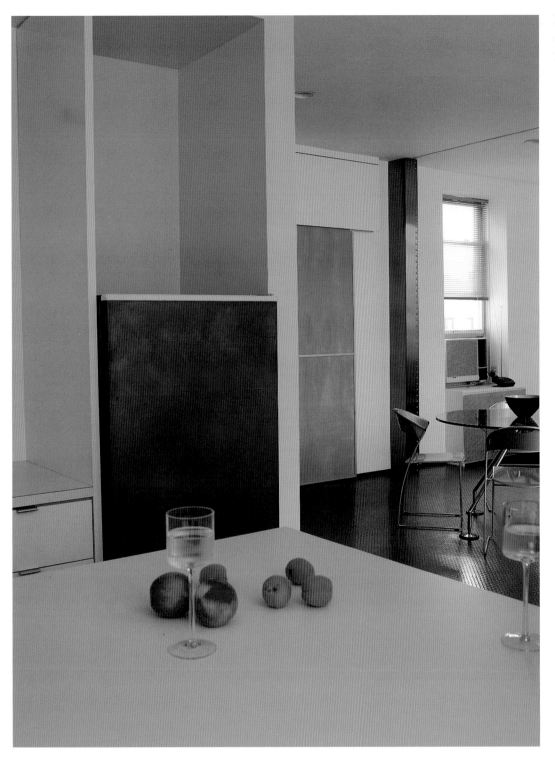

FOREWORD

In cities where the population is continuously growing, it has been increasingly difficult for average people to find large apartments within their financial reach. Thus it is not uncommon for such people to collaborate with architects who offer both marvelous ideas and practical solutions in order to find a comfortable lifestyle in their restricted environments.

Yet, while many city dwellers have to deal with spatial challenges in their houses and apartments, major contemporary architectural and interior magazines rarely inform their readers how to live spaciously on limited budgets.

In recognizing the importance of recent architectural trends, *Big Ideas for Small Spaces: Studio Apartments* introduces to its readers a variety of apartment projects and discusses the ideas which their architects nurtured, proposed, and realized in their intricate designs. The book unfolds fresh examples of recently redesigned apartments in the United States and in Tokyo, Melbourne, London, and Paris, all of which manifest unique, successful, and provocative solutions to their confined space.

Since the early 1990s, and after experiencing the end of Post-Modernism, architects have increasingly looked back to Modernism, and particularly to the works of Le Corbusier and Mies van der Rohe, for design inspiration. Architects are not simply following the plans and styles of the first half of the twentieth century, but are boldly reinterpreting them by adding variations and twists to Modernist planning, and by taking advantage of new

materials, the use of which has been dramatically increased during the last decade. They do not hesitate to use color in order to enhance the sense of space, as Le Corbusier did several decades ago.

The apartments featured in this book reveal the architects' preference for either eloquent simplicity (not dry, vague space) or subdued complexity (not bustling liveliness). While the often limited budgets for these projects do not allow architects any radical, unprecedented use of new materials, they create ways to reflect the nature of such materials and successfully produce unexpected, surprising effects, all the more so when combining such effects with inventive plans, color, and lighting.

The first and predominant challenge confronting these architects is the confines of small space itself. It is notable that as a solution to this problem, many projects in this book exemplify the use of distinctive areas defined within a single open space, each area serving a clearly different function as if it were a separate room built in a full-sized home. The owner of the studio apartment designed by Robin Elmslie Osler, for example, asked the architect to create sections within an open space for sleeping, working, and entertaining. The architect did so, yet unified the entire space by employing monochromatic tones and materials which appeared weightless: brushed steel, special acrylic paints, diamond-patterned vinyl sheeting for the floor, and a rubber screen curtain. As a result, the apartment is perfectly functional and has an extraordinary sense of light and space.

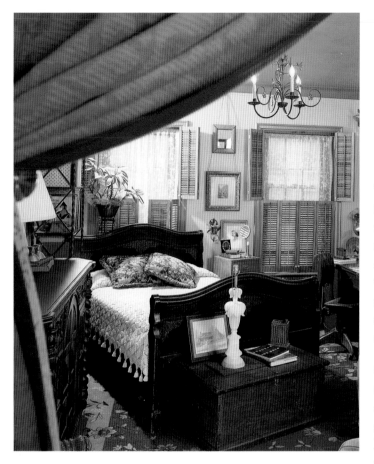

William Green's studio apartment reflects a traditional, gravitational look, a total antithesis of Osler's. Fundamentally, however, their studios share the same design principle: a unified space composed of functional, distinctive areas, which in this case include bedroom, office, living room, dining room, and library. For a period of more than a decade, Green has accumulated the constituent elements of his studio–furniture, textiles, paintings, mirrors, and various decorative objects–most of which are similar in color, resulting in a sense of cohesive unity.

The most dominant elements in the studio designed by Dean & Wolf are two screens that define distinctive areas.

They also function as architectural implements that connect these areas to the whole. The longer screen dividing the work space and meeting/dining area has a horizontal opening which de-compartmentalizes the space, creating additional vistas and spatial relationships. The vertical slit opened on the corner of the shorter screen allows one to cast a long diagonal glance from the secluded sleeping area to the opposite side of the apartment, creating a sense of space.

One setting can have two or more functions, by the creation of convertible areas that are sometimes clearly defined and at other times part of a single space. Such an apartment can have both flexibility and diversity. James Brehm's studio apartment is composed of five separate parts: library, study/dining, living, entrance, and kitchen. Each part crosses over to another, and the whole is unified by a sinuous wall. One section of the wall conceals a Murphy bed which opens into the living area at night. In the main room of the apartment, designed by Parsons + Fernandez-Casteleiro, a large built-in shelf hides a Murphy bed. When the bed is opened, a rolling translucent panel--made of two layers of sanded polycarbonate held together by nuts and bolts--divides an open living/dining space into two distinct areas: a guest bedroom and a breakfast room where the owners of the apartment can eat without disturbing the privacy of their sleeping guests.

Translucent walls are another way of creating a sense of space, even when there is nothing behind the wall. With

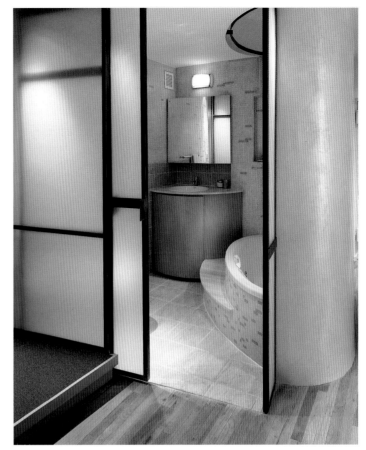

Left: The sleeping area in an apartment by William Green. Photo by John Nasta.

Right: The shower/bathroom in an apartment by Via Architecture Studio. Photo by Lynn Massimo.

such devices, a small space need not seem restricted, but can appear to extend into its neighboring areas. The rolling translucent panel designed by Parsons + Fernandez-Casteleiro, for the apartment noted above, for example, physically divides the living/dining space into two areas, but the light coming through the translucent panel makes one aware of the space behind it. A studio apartment by Via Architecture Studio features two opalescent Mondrianesque panels simply composed of translucent glass with iron frames. One divides the sleeping area and the living area, while the other functions as a bathroom wall facing both living and sleeping areas. When in the living area, one can sense the depth of the sleeping area behind the translucent partition. When lit from the inside, the bathroom becomes a large lighting box, suggesting that the apartment has another room. Similarly, in the small apartments designed by Mark Guard, the bathrooms play an important role. The architect uses Priva-lite electric glass for bathroom walls, through which one can view the living space. At the flick of a switch, the wall changes from clear to opaque, thus re-establishing the privacy of the bathroom.

When applying these techniques, most architects employ simple but meticulous detail, taking advantage of straightforward materials. This simple detail helps to make a small space appear larger, by reducing visual clutter. In his own studio apartment, architect Belmont Freeman removed the classical moldings of the ceiling in order to avoid defining the boundary of the ceiling and walls, and so created a sense of expansion. The living/dining/sleeping area is smoothly connected with the kitchen by an extending counter of refined simplicity. In the penthouse studio created by Australian architect Martine Seccull, the Donald Judd-like kitchen island hovers in the open space. While it defines the kitchen area, the lightness and plainness of its design makes it so unobtrusive that the kitchen area remains as a constituent element of the living space.

In some of the projects presented in the book, the architects chose to enliven non-distinctive rectangular apartments by designing round or sinuously shaped walls to create irregular movements within the spaces. In the studio apartment designed by Via Architecture Studio, mentioned above, the central focus of the apartment—the

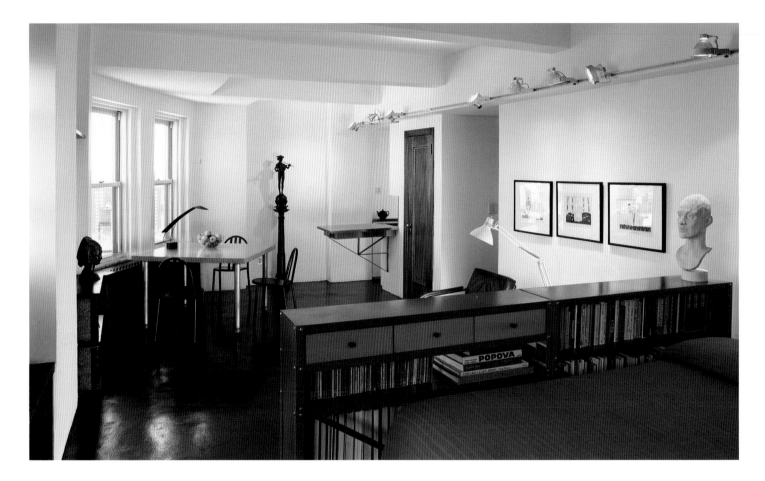

bathroom—has a convex wall. Located at the entrance to the apartment, the wall blocks an immediate view of the apartment and instead gently leads the inhabitant to a striking, diagonal encounter with the open space. In James Brehm's long, rectangular studio apartment, also mentioned above, the meandering wall hides a work desk, a Murphy bed, and a bathroom within, and adds a sense of elasticity to the space. In similar vein, in the project designed by AC2, spatial curvature is created by the placement of two translucent, round walls made of Lumasite acrylic panel. By the skillful placements of these walls, which reflect subtle shifts of light from day to night, the architects produce lively divergences between open and closed, solid and flexible, and particularly high

and low in speed as inhabitants move within the space.

Deliberate use of color and light is also critical when making small projects provocative. Color is the predominant design feature in Leo Blackman's project. Here the architect plays with vivid colors for furniture, decorative objects, and utensils. He employs light pastel colors for walls and ceilings. The vivacious contrast between the strong colors of furnishing and the surrounding pale colors of the walls and ceilings expands perceptual spatial dimensions of the apartment. Ken Kennedy, on the other hand, uses many blocks of color in order to accentuate the function of each defined area in the large open space of his one-bedroom apartment. By illuminating walls

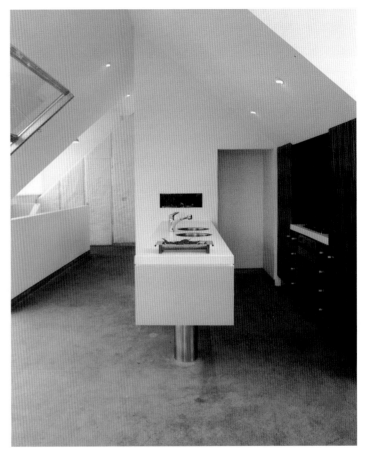

and ceilings with ambient uplights, often installed in niches on walls, the architect successfully gives accents to the apartment, creating pleasant syncopation within the entire space.

There are interesting projects in which architects incorporate surrounding landscapes, a technique familiar to landscape architects as "borrowed landscape." In his apartment noted above, Belmont Freeman demolished a bedroom wall and designed a rectangular studio. In doing so, he created a long visual flow from the kitchen, which is at one corner of the open space, to the large terrace located at the diagonally opposite corner. The viewer's gaze is naturally drawn toward the terrace, which overlooks the magnificent view of the Hudson River. For their one-bedroom apartment, the architects of Via Architecture Studio located the oversized bathroom at the center of the apartment and made it open to an urban landscape. The architects envisaged that when taking a shower, the owner of the apartment will leave the large sliding door of the bathroom wide open, enjoying an al fresco bathing experience and a sublime panoramic view of lower Manhattan. At the studio apartment designed by the same architects, a revolving, floating vertical mirror attached to the edge of the sleeping area catches an oblique view of the skyline visible from the main window, projecting it into the interior, thus blurring the actual boundary between interior and exterior space.

In different vein, but creating a similar effect, James

Brehm hung a drapery at a near right angle to an adjacent floor-to-ceiling mirror, making the drapery look twice as wide. The drapery is situated directly in front of a wall in order to create the illusion of space beyond it.

Big Ideas for Small Spaces: Studio Apartments illuminates how skillful contemporary architects are creative in using materials, light, color, and movement to transform very confined, ordinary settings into exciting, innovative, and spacious dwellings.

Il Kim

STRAIGHT CURVES

James Brehm

The architect's program for his own apartment was intense, requiring a design that would accommodate living, working and entertaining and provide ample storage. While the apartment is barely 400 square feet, the architect has created a space that feels generous in size. He has successfully transformed the most common and least interesting of studio apartments—the basic rectangle with a door at one end and windows at the other—into a sophisticated, multi-purpose apartment. He often holds casual parties here and he can seat eight for a formal dinner. There is a fold-out bed and a 14-foot-long convertible sofa that can sleep two.

Above: Kitchen detail.

Right: A view from the entrance to the study/dining area. A fold-out bed is concealed behind the curved wall. The ceiling continues beyond the top of the wall, giving the appearance that the wall is a piece of furniture contained within the "box" of the apartment.

Photography: Catherine Bogert

BIG IDEA: Furnishings are kept to a minimum. Everything is built in except for the dining table and chairs, thus maximizing floor space. The curving red oak wall, which meanders from the kitchen to the window wall, is the dominant element and principal organizing feature of the apartment. It stops short of the ceiling, and thus appears to be a piece of furniture rather than a structural element. The vertical grooves in the wood give the wall added height and make the wall appear seamless, concealing the fact that there are doors which open to the bathroom, a fold-out bed, a writing table, and an office center.

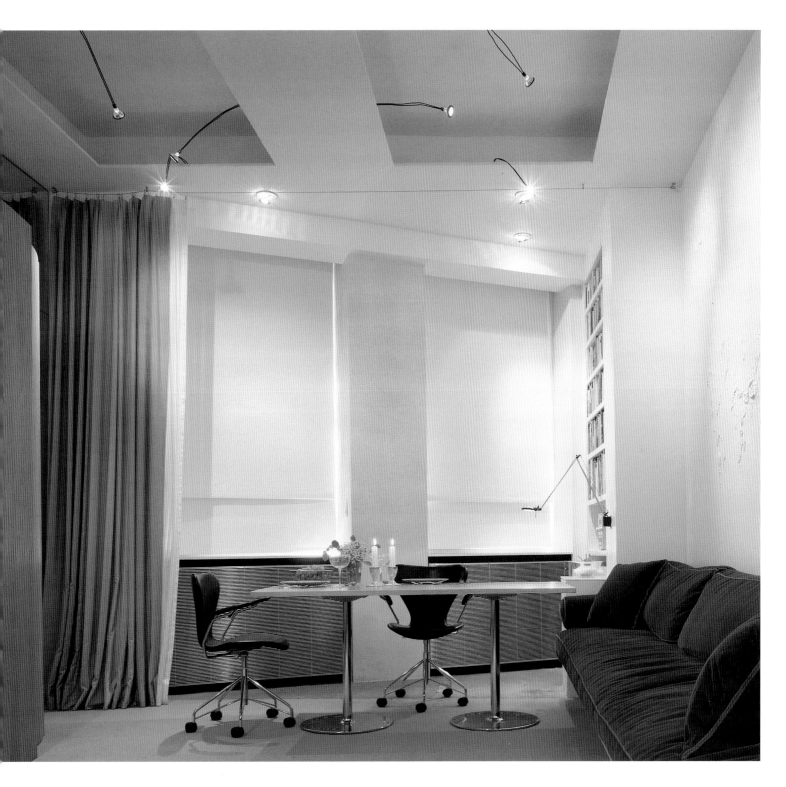

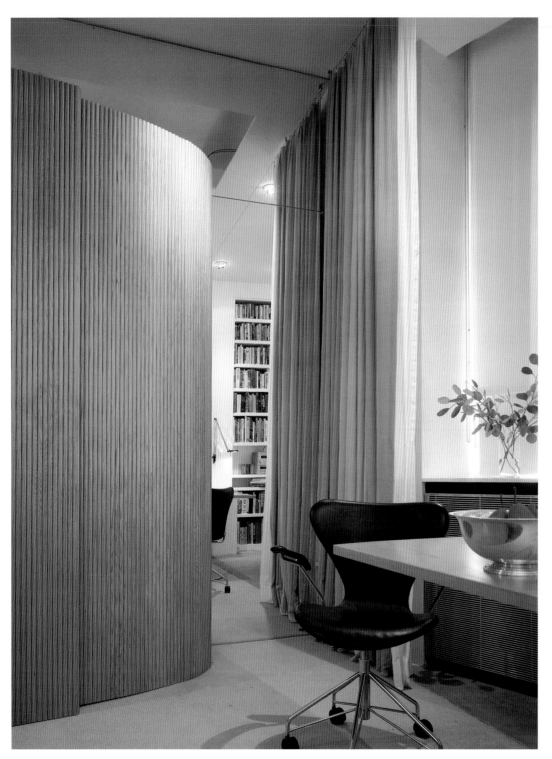

Left: A floor-to-ceiling mirror behind the curved wall creates an illusion of another room, reflecting the bookcases on the opposite wall. The curtain, with its vertical folds, appears to continue into the mirror, reinforcing the illusion.

Right: Beside the bookcases is a three-dimensional map of the world which gives texture to the wall behind the sitting area.

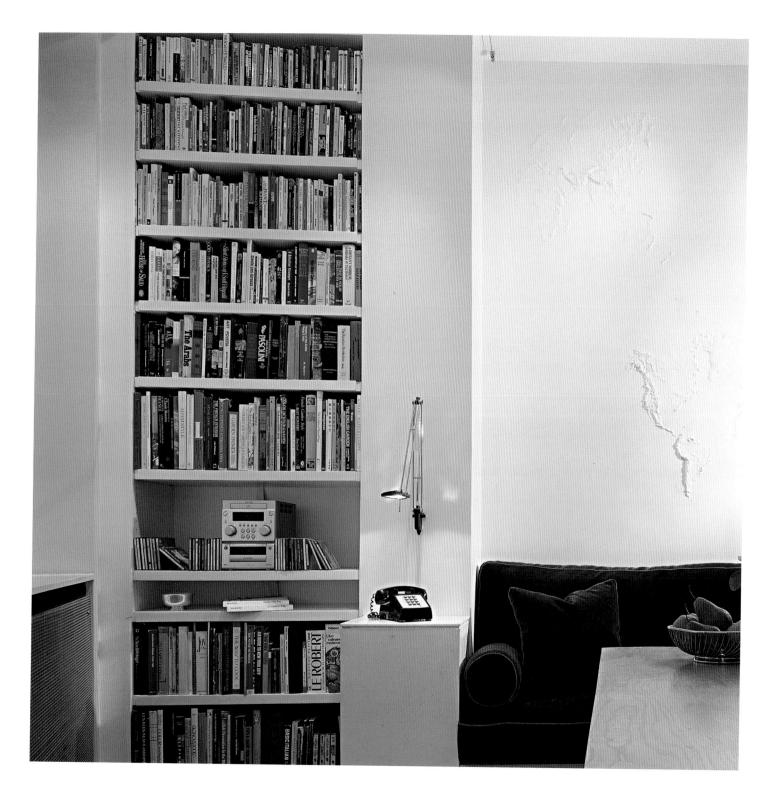

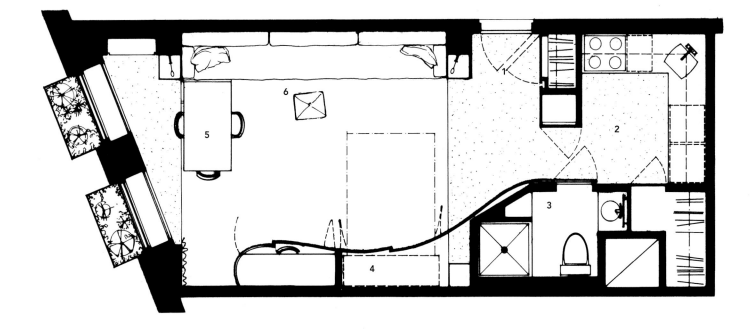

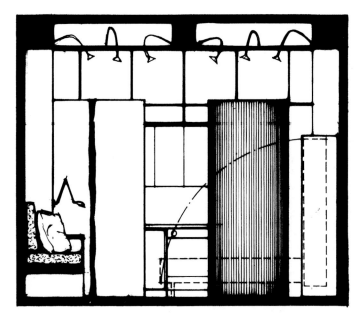

1. Entry
2. Kitchen
3. Bath

4. Murphy Bed
5. Study/Dining
6. Living Area

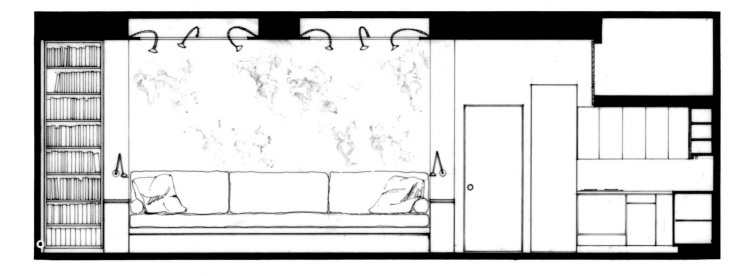

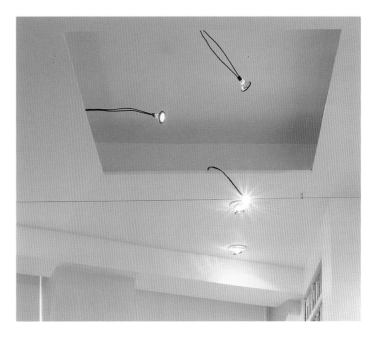

Right: A detail showing the randomly placed lighting fixtures against the orthogonal layout of the ceiling.

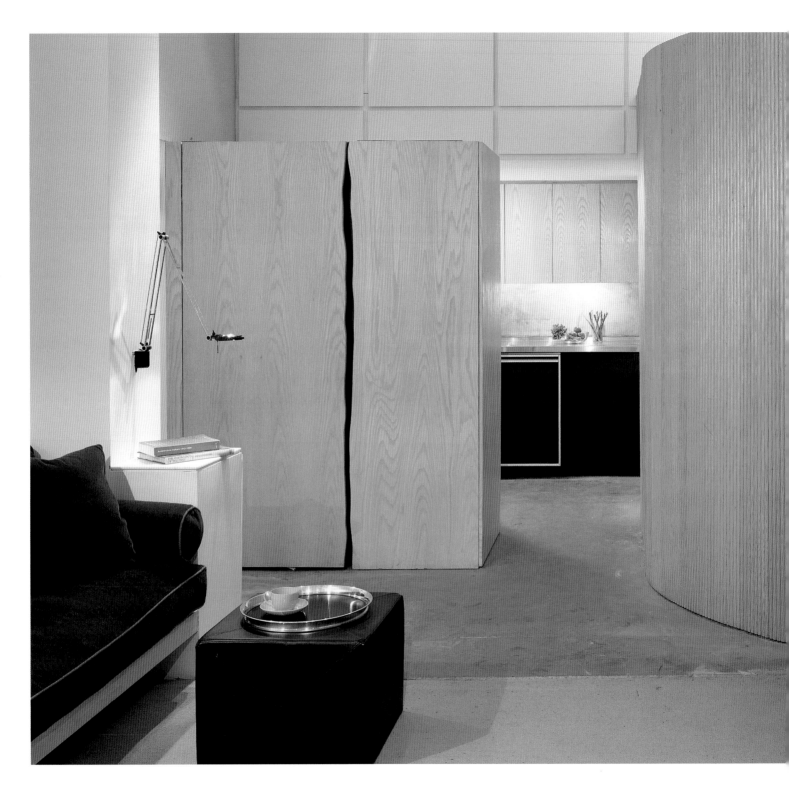

Left: From the sitting area, the kitchen is visible at the far end of the apartment. The curved wall creates a sense of movement in the rectangular space. On the right, the wall curves outward to accommodate the bathroom.

Below: With the Murphy bed extended, a small alcove accommodates a reading lamp and books.

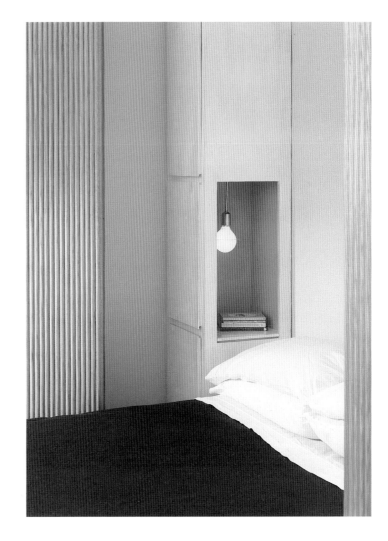

DESIGN WITH HUMOR

Marco Pasanella

Armed with a keen sense of humor, the architect redesigned this small apartment for himself. "With park views and high ceilings, the challenge was not to create a great space," he explains. "It was already pretty great. After a 12-hour day in the studio, the last thing I want to see when I get home is D-E-S-I-G-N. The key, I realized, was to think small."

The apartment rewards slow investigation. Looking around the soft sage-colored rooms, one discovers humorous touches at every turn. Much of this humor derives from the double-function furniture designs for which the architect is known. But, as Pasanella explains, "A lot of the things that make you smile, also make a lot of sense." The bedroom, for example, gains extra storage with his "Reading Settee" that combines a lounge chair and a bookshelf. In the kitchen, Pasanella's "Stowaway Chairs" provide built-in storage for newspapers and magazines.

BIG IDEA:

The design budget for this apartment was modest. No walls were removed, all of the plumbing stayed where it was, doors and closets were left untouched. Instead, the architect chose a subtle, monochromatic color scheme as a backdrop for a myriad of details, both humorous and practical, that transform and celebrate the space. Details such as the non-functioning ladder which serves to visually push the ceilings even higher than they are; the curtain with the hole cut in the center that retains privacy while expanding the view; and the multi-purpose pot rack that accommodates pots and pictures.

Right: Humor abounds in the many details in this apartment: a ladder leading to a vase of chocolate biscuits (top left); a small wall safe with velvet-lined drawers in the bedroom (top right); several curious objects on the mantel including a stuffed goldfish (bottom left); and elaborate monograms on each towel that describe its function.

Photography: Paul Warchol

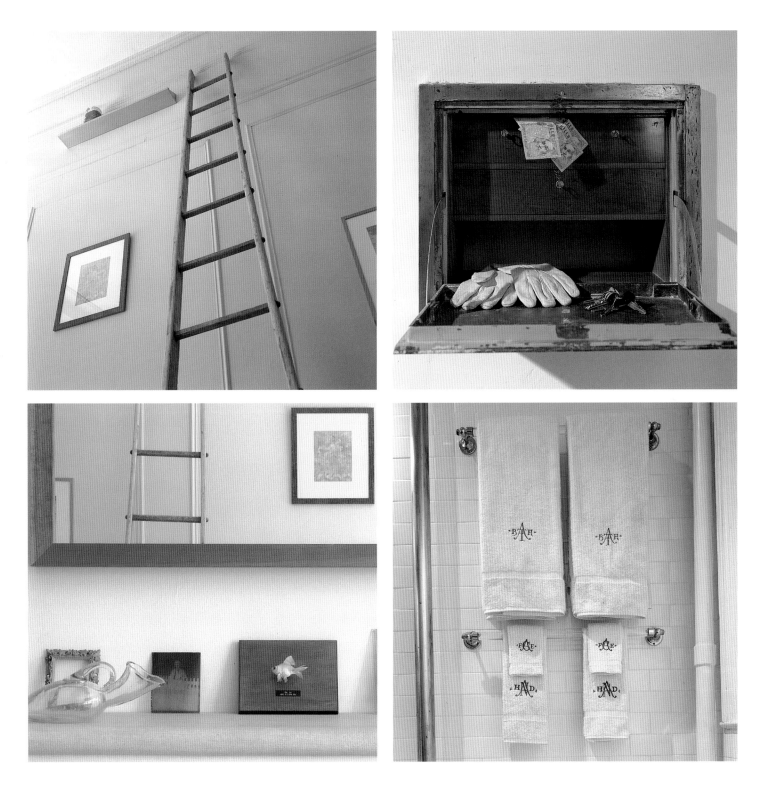

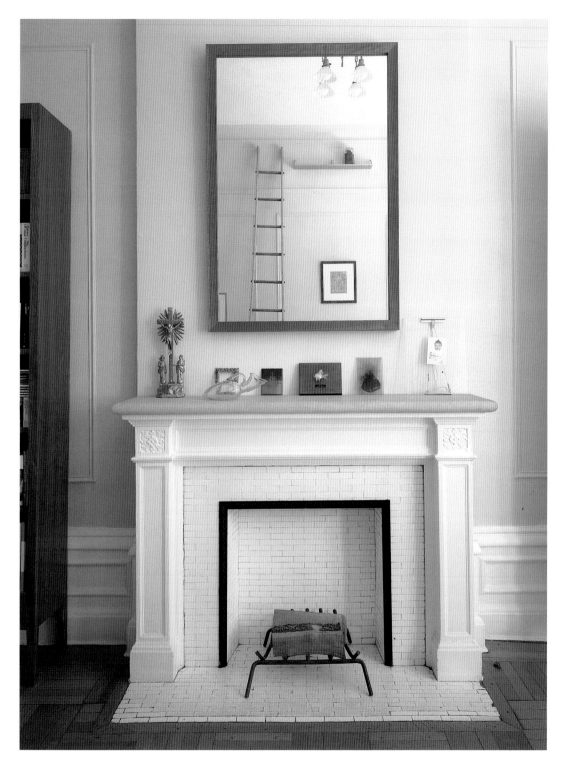

Left: The subtle humor used in decorating the apartment is on full display on the mantel. Note the ladder to the cookie jar reflected in the mirror.

Right: In the entrance hall are two pieces of double-function furniture designed by the architect: "Flower Table" and "Picture Table."

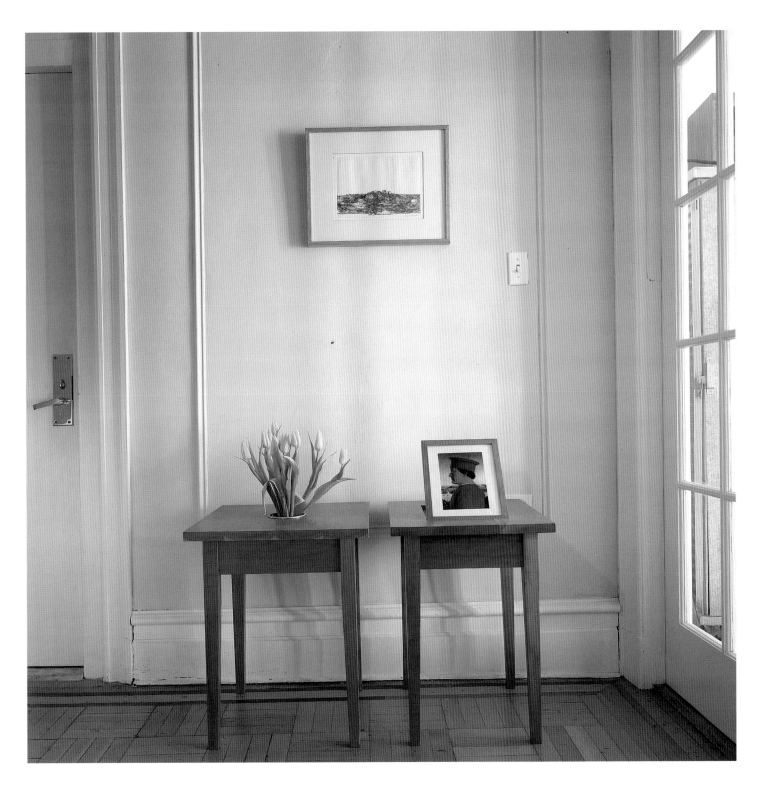

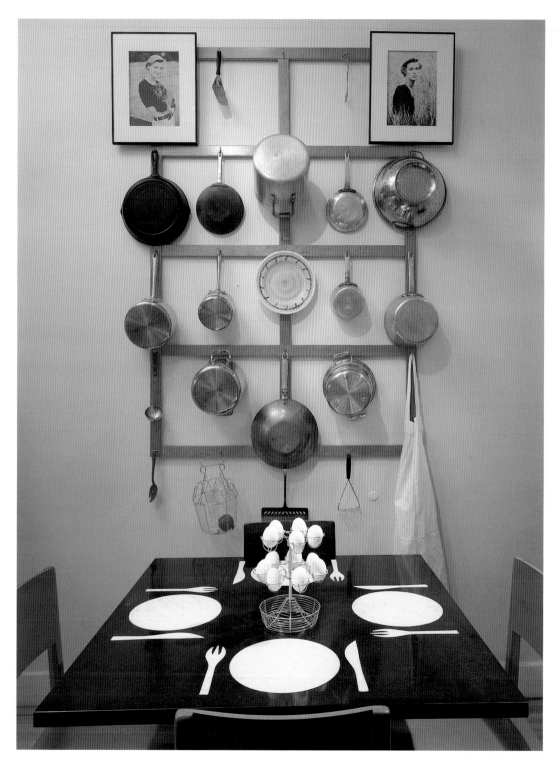

Left: In the kitchen are Pasanella-deigned pieces: the pot rack which is used to hang pots and photos of loved ones; the "Soupson Table" with inlaid place settings; and "Stowaway Chairs" equipped with shelves to stow newspapers.

Right: The humor continues in the bedroom with a curtain featuring a hole which Pasanella says "frames a view out, but doesn't let passing bus drivers see in." The architect designed the "San Gimignano" bed. The wall safe is by the window.

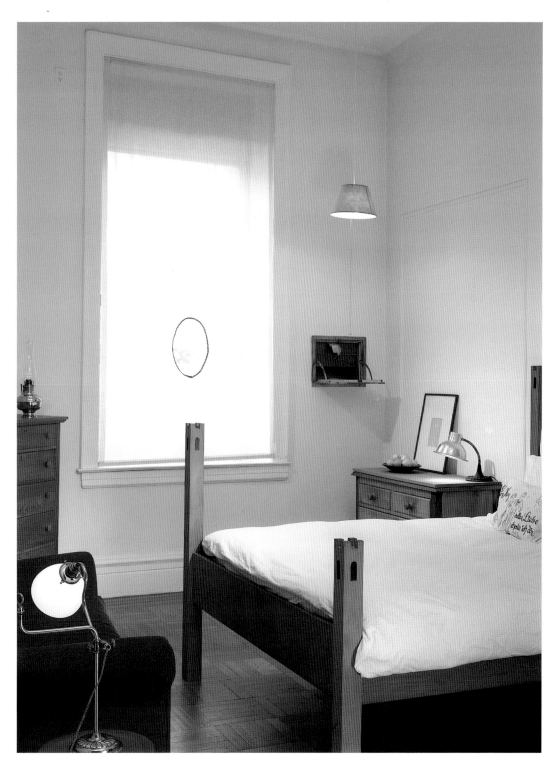

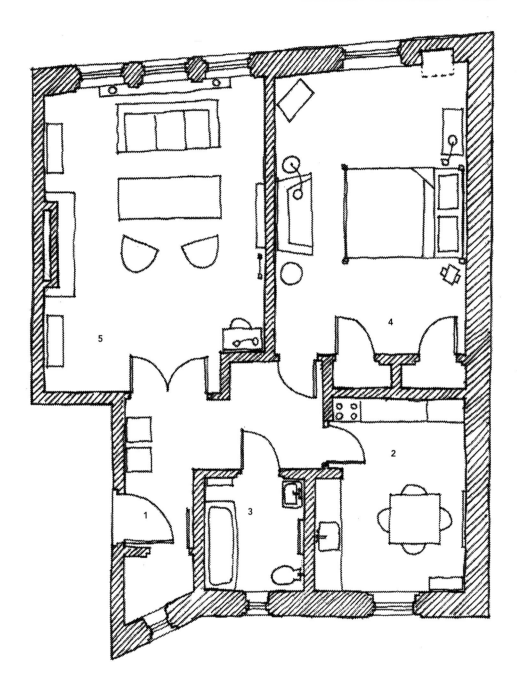

1. Entry

2. Kitchen

3. Bath

4. Bedroom

5. Living Room

Right: A close-up of the hole in the bedroom curtain which expands the view while protecting privacy.

TRANSFORMABLE SPACE

Mark Guard

This apartment explores ways of maximizing available space through flexibility of use. It can be transformed from one bedroom to two bedrooms or to no bedrooms at all, providing a large space for living or working. The master bed and the guest bed are contained in two free standing boxes. A third box contains the closet. When the doors to these boxes are open, they serve as privacy screens for the sleeping areas.

These three free-standing boxes, which enclose the bathroom, are bisected by a stainless steel table that functions both as a dining and work table.

A limestone floor provides a durable surface for both living and working. To achieve visual clarity, the space is painted white and detailed in a simple manner.

BIG IDEA: The bathroom is the central focus of this space. It is enclosed by three fixed boxes containing two beds and a closest. A long steel table bisects it and the bathtub is set into the table. When sitting in the tub, one has the luxury of looking through the living space to the windows. A Priva-lite electric glass separates the bath tub from the living area and a flick of a switch changes it from clear to opaque, creating privacy when desired. In addition to the stainless steel tub there is a sculptural, free-standing glass shower with a stainless steel dished shower base and a stainless steel washbasin adapted from a large mixing bowl.

Right: The box in the center of the living area contains the bathroom. In front is the dining area and to the right is the storage wall, which runs the length of the apartment. It contains everything: an entertainment center, kitchen appliances, storage, laundry, dressing table, closets, and a wash basin.

Photography: Alan Williams

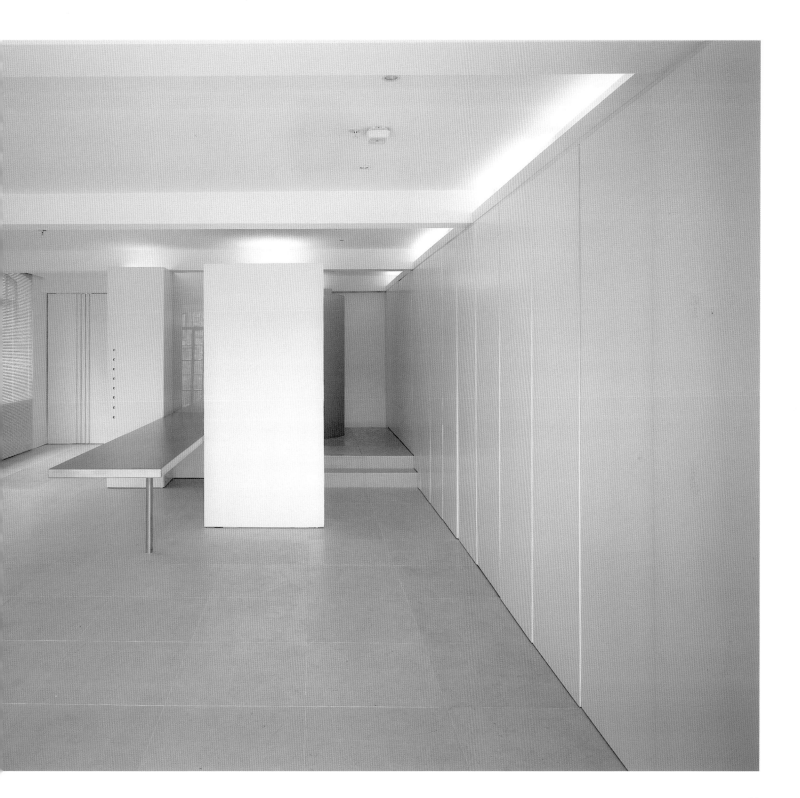

Below: The three free-standing boxes, which enclose the bathroom, are bisected by a stainless steel table. The bath, set into the table, is separated from the living area by Priva-lite electric glass which can be switched from opaque to clear, giving a long view across the living area when sitting in the bath tub.

Right: The doors to the kitchen area can be folded back, exposing the sink, cooking area, and a bar.

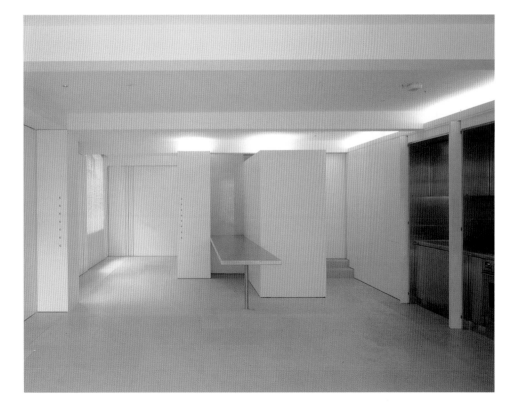

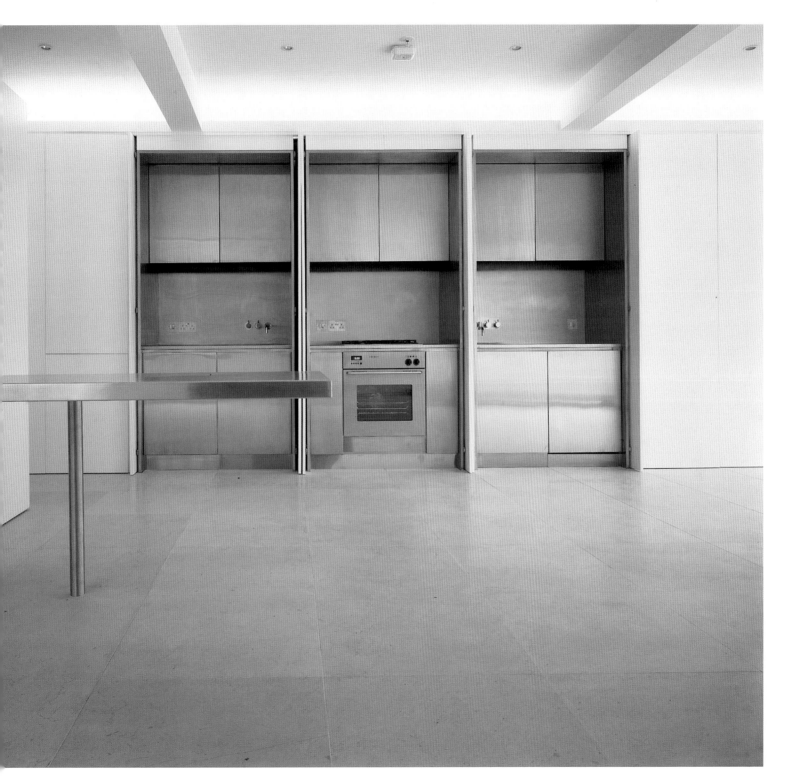

AXONOMETRIC

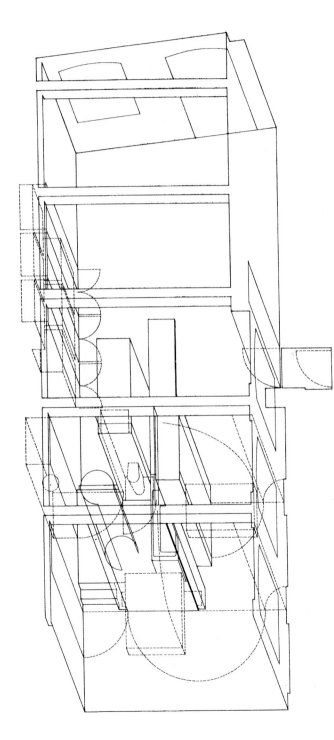

THE TRANSFORMABLE
APARTMENT

Sleeping

Dressing

Overnight guest

Bath with a view

Living/dining

Working

Right: The shower is a curved, frameless, free-standing, laminated, and sandblasted glass enclosure. The bath tub is stainless steel.

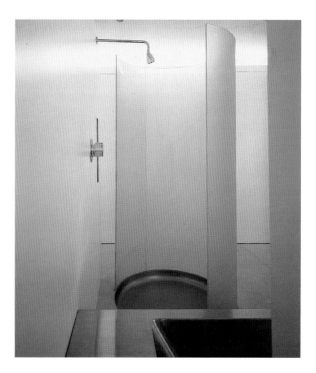

FLOOR PLAN

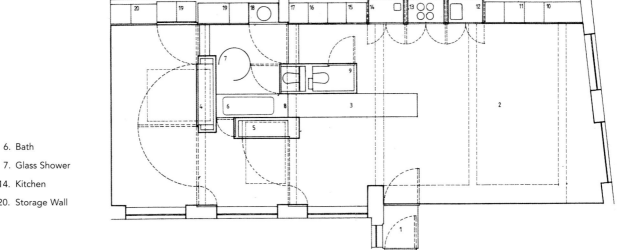

1. Entry
2. Living Area
3. Dining Area
4. Master Bed
5. Guest Bed
6. Bath
7. Glass Shower
12-14. Kitchen
10-20. Storage Wall

YACHT ARCHITECTURE

Diana Viñoly

In this renovation, the designer's goal was to convert a very small two-room space in a former hotel into an apartment with a bedroom, a functional kitchen for the client who is an amateur cook, a dining space for six to eight people, and a living area large enough to accommodate an upright piano. In considering this challenge, the designer said that she thought of this apartment as a boat where a number of activities must be integrated into a very restricted space. "I was inspired," she remarked, "by yacht architecture."

The apartment reads as a continuous space from one living area to the next without visual interruptions. The entire apartment is visible from the entry foyer, which is positioned in the middle.

BIG IDEA:

The custom cabinetry and doors are essential to the success of this renovation. The long wall unit in the living area, the sliding translucent screens to the bathroom, and the wall unit in the bedroom are all constructed of maple, chosen because of its cost and color. Stainless steel hardware is placed vertically at the edge of the doors making the wood cabinets appear as a continuous surface.

Right: The kitchen, dining area, and living area as seen from the entrance. Slate flooring is used in the kitchen and to mark the small entrance. Lighting is used to create a sense of spaciousness by highlighting certain areas using dimmers.

Photography: Fred R. Conrad/NYT Pictures

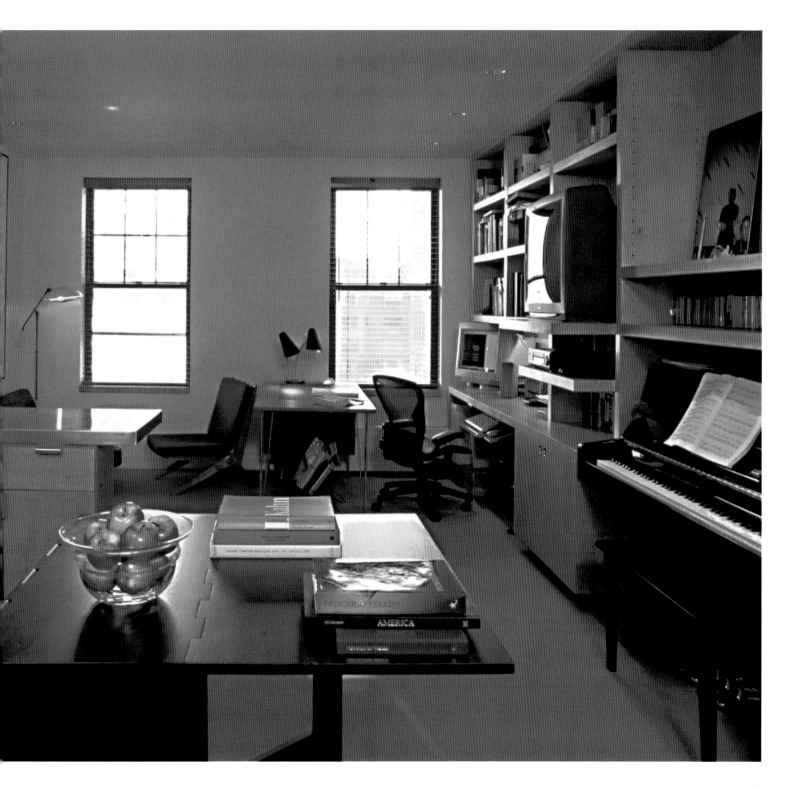

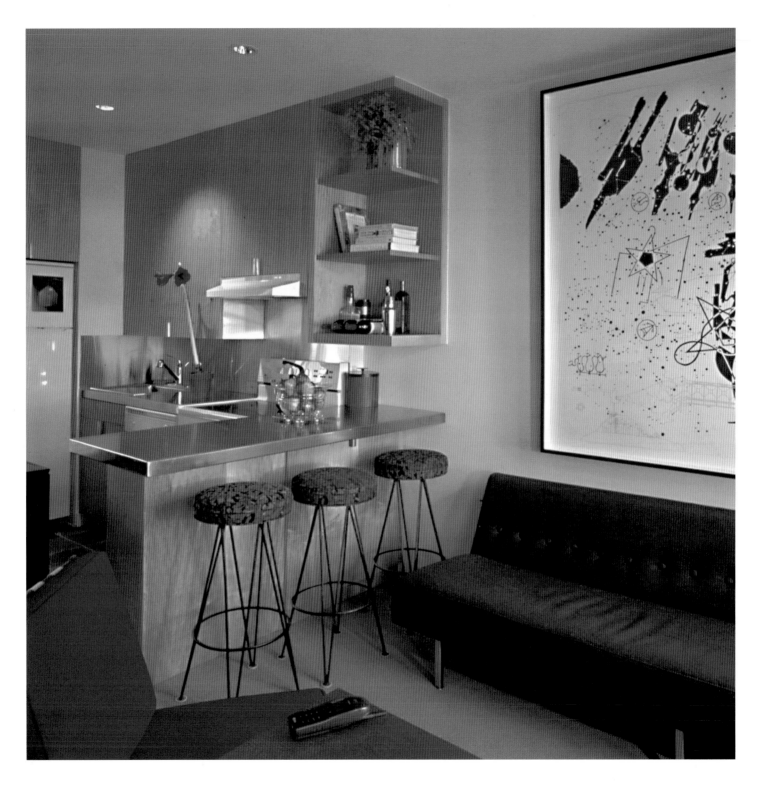

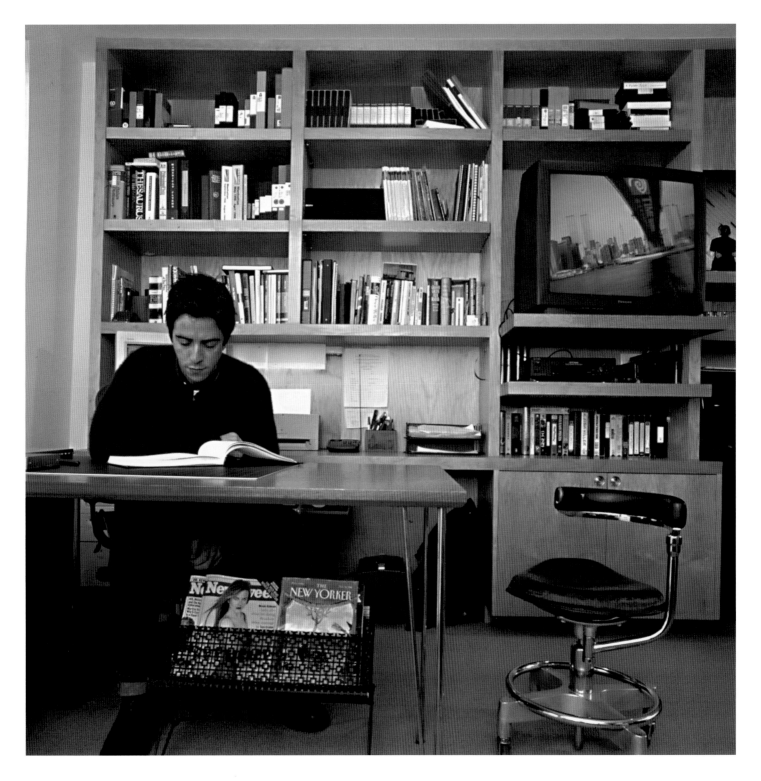

Previous pages (Left): The kitchen as
seen from the living area. The stainless
steel countertops and maple cabinetry
give a bright, contemporary look to the
space. (Right): The living area doubles
as an office.

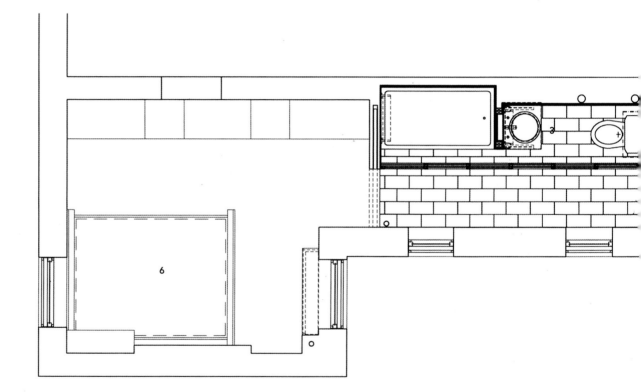

1. Entry 4. Closet
2. Kitchen 5. Living Area
3. Bath 6. Bedroom

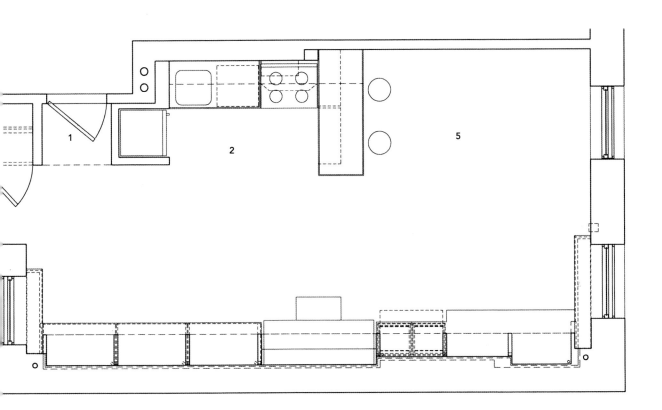

INTERIOR ELEVATION

INTERIOR ELEVATION

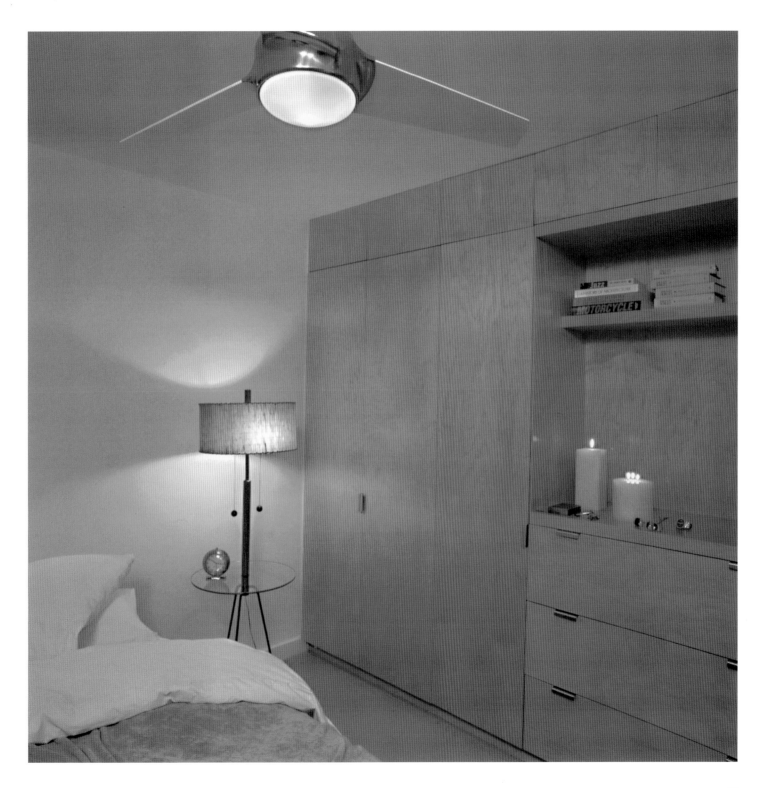

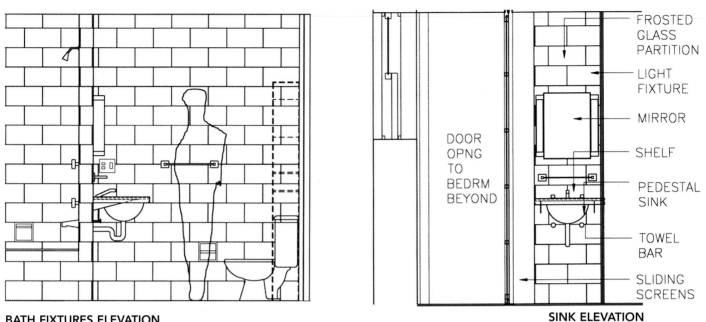

BATH FIXTURES ELEVATION

FROSTED
GLASS
PARTITION

LIGHT
FIXTURE

MIRROR

SHELF

DOOR
OPNG
TO
BEDRM
BEYOND

PEDESTAL
SINK

TOWEL
BAR

SLIDING
SCREENS

SINK ELEVATION

BATHROOM FLOOR PLAN

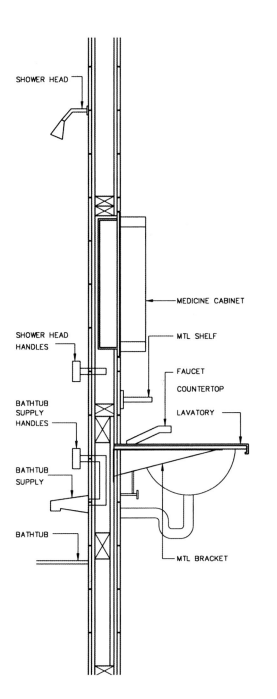

SHOWER HEAD

SHOWER HEAD
HANDLES

BATHTUB
SUPPLY
HANDLES

BATHTUB
SUPPLY

BATHTUB

MEDICINE CABINET

MTL SHELF

FAUCET

COUNTERTOP

LAVATORY

MTL BRACKET

**COUNTERTOP AND SHELF
DETAILS**

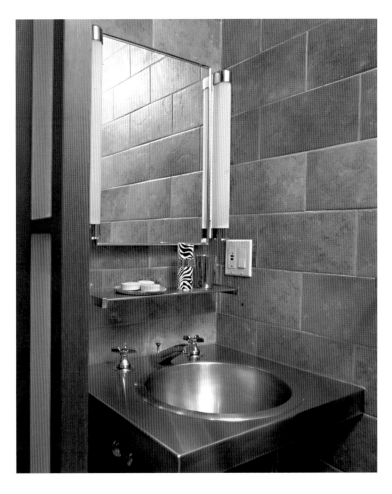

Above: The stainless steel sink and top
give an industrial look to the bathroom.
Just visible to the left are sliding doors
with plastified rice paper that run the
length of the bathroom. They allow light
to filter in from the windows opposite.

RAW MODERNITY

Diane Lewis

The building in which this apartment is located was constructed in the mid-1800s as a woodworker's shop. The architect wanted to create a studio and apartment for herself that amplified the existing qualities of this rustic structure. The apartment is located above the studio on the third floor. The wood beams remain exposed, with insulation and plaster inset between them. The exposed brick walls were left unfinished.

The floor plan is a modular 7-foot, 5-inch square grid of white concrete. The walls are all bookcases or cabinets made of plywood with negative corner details. A free-standing walk-in closet is entered from the bedroom. The architect's studio is on the floor below.

FLOOR PLAN

1. Entry
2. Living Area
3. Sleeping Area
4. Dining Area
5. Kitchen
6. Bath

Right: The living area features two chairs by Gerrit Rietveld and a third by Harry Bertoia.

Photography: Paul Warchol

BIG IDEA: The architect wanted to create the total volume of the apartment as a visceral space. No interior walls come in contact with the load-bearing exterior walls. All of the interventions within the apartment are aligned or projected from the windows. One can freely walk around the perimeter of the apartment since the bath, kitchen, and bedroom are gathered within the core of the space.

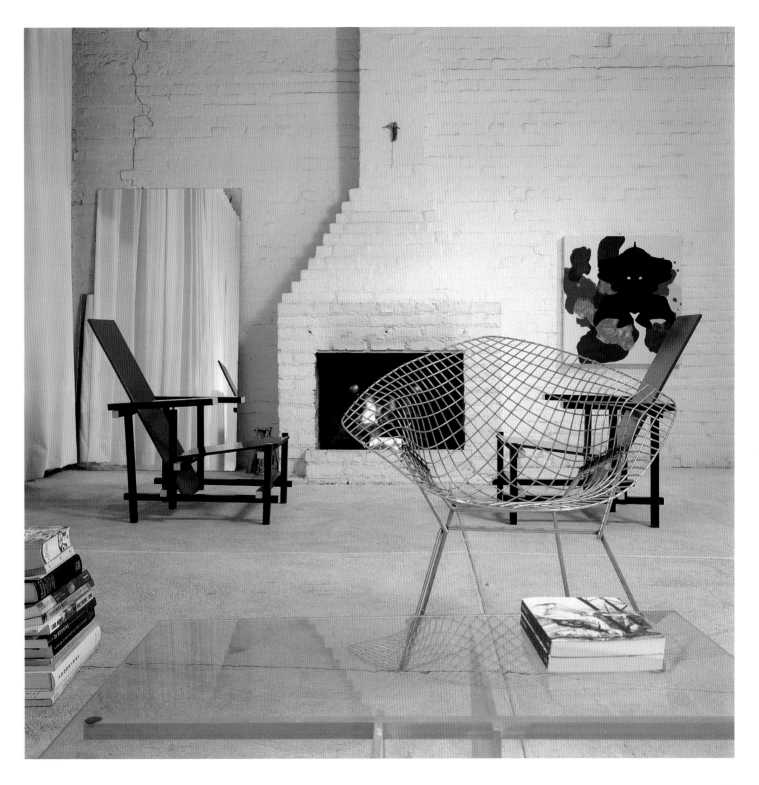

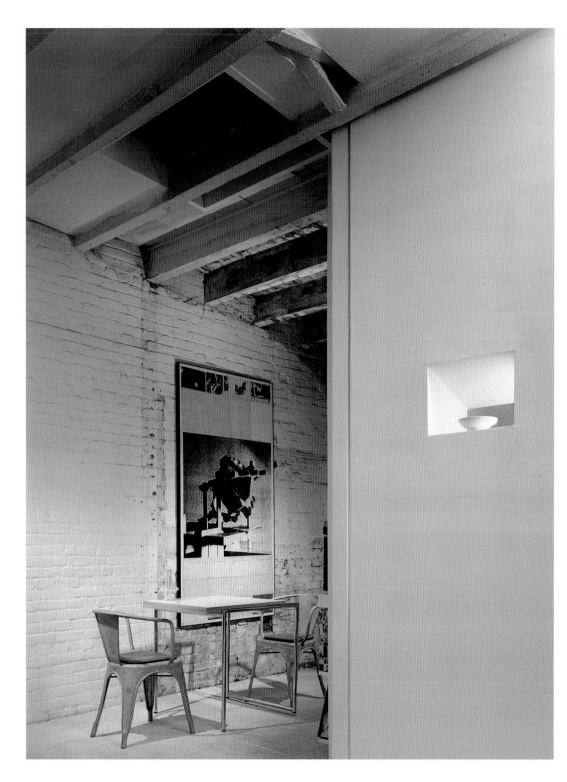

Left: A detail of the wall separating the living area from the kitchen. The small opening is placed on the axis of a window, bringing light into the kitchen.

Right: A view of the same wall looking toward the sleeping area. All interior walls are either bookcases or cabinets made of plywood with negative corner details.

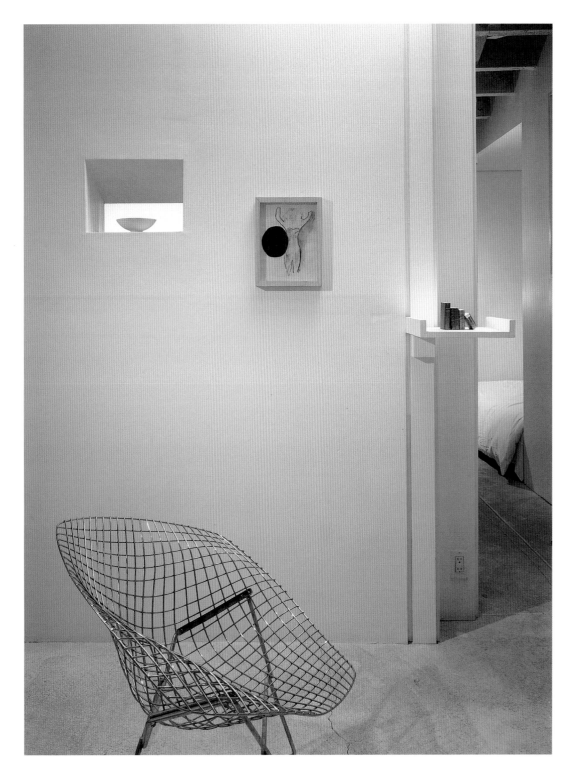

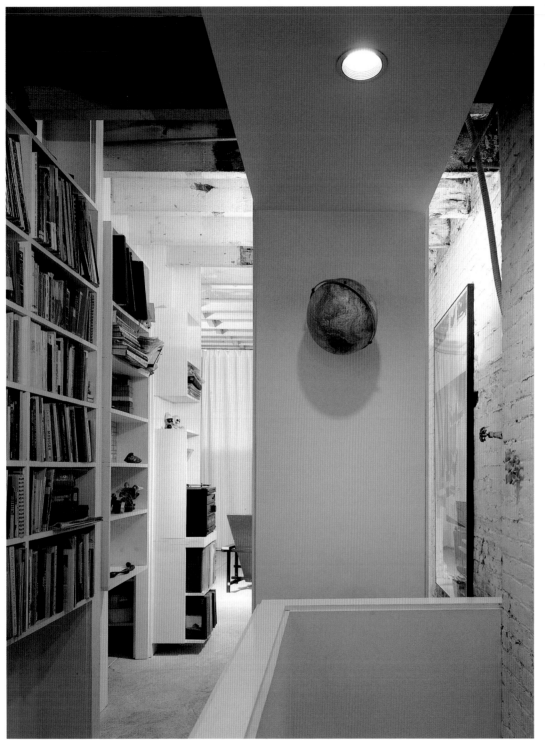

Left: A view from the landing of the staircase, which is the entrance to the apartment, to the living area.

Right: In the sleeping area, the ceiling forms a canopy over the bed. A sliding wall screens the window at night.

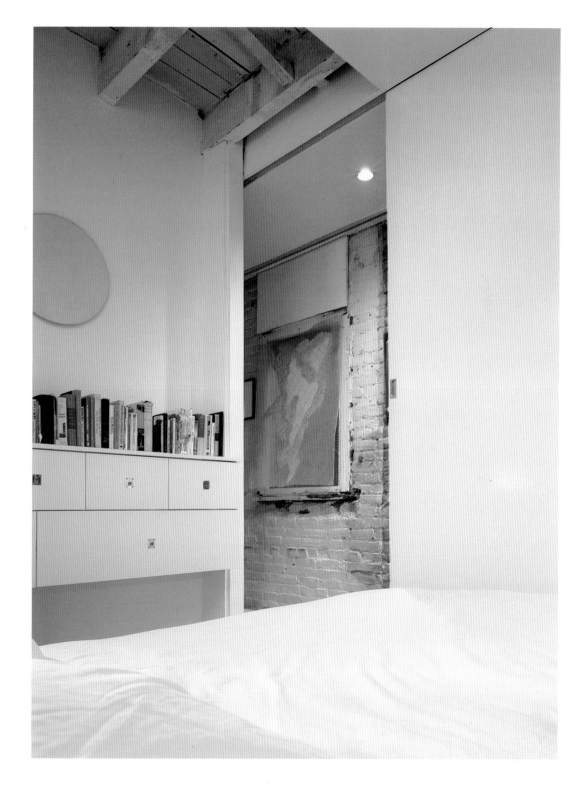

Right: The floor plan is a 7-foot 5-inch square modular gird of white concrete. The wood beams are exposed, with inset elements of insulation and plaster between them.

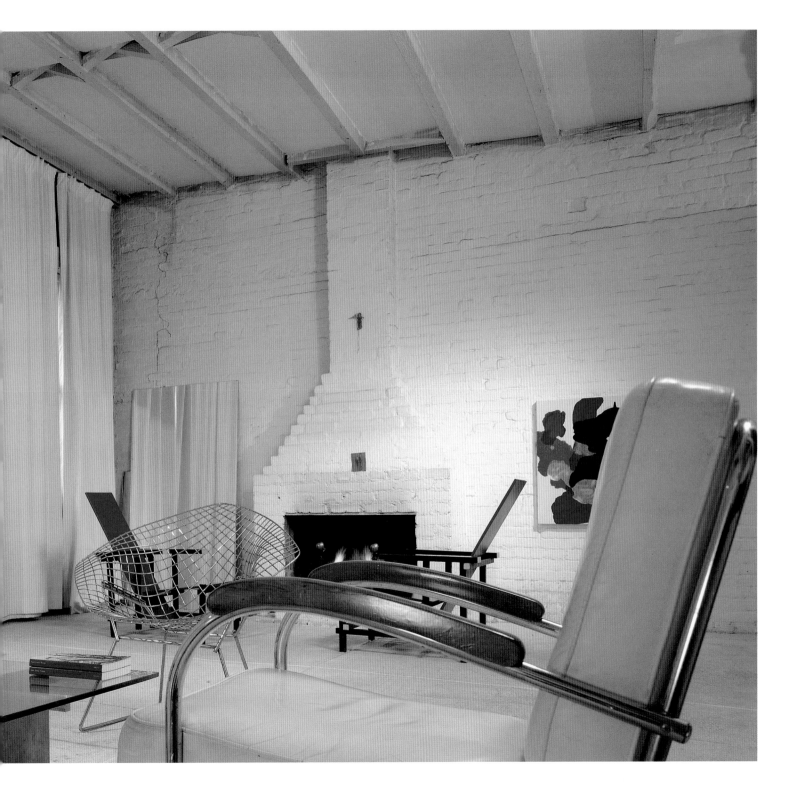

LIVING AND WORKING IN COLOR

Leo J. Blackman

The architect designed this living and working space for himself and a partner by combining a tiny one-bedroom apartment and an adjacent studio apartment that together total only 850 square feet. It is located in a building constructed in 1928 and was originally used as a nurse's residence. Since the budget was modest, much of the existing plan was retained. The walls between the living room and bedroom were demolished to create an open L-shaped space for living and dining. The bedroom was relocated to the studio apartment, where four new closets were constructed along with a hallway leading to a new office created from the studio's kitchen and bath. Much of the furniture and many of the light fixtures were designed by the architect.

BIG IDEA: In this apartment, several small ideas were combined to help fulfill the architect's desire to have a spacious living and working environment in a limited space with an even more limited budget. Painting the trim, ceilings, and walls in deep, strong colors blurred the edges of the rooms, making them appear larger. A banquette and a mural were added along one wall of the dining area, making the space appear wider. Custom bookshelves in the living room and dressers set into alcoves in the bedroom maximize storage and reduce visual clutter.

Right: From the entrance hall, the living/dining area is open and spacious following the removal of earlier partitions. The mural at left was painted by Ladd Spiegel.

Photography: Paul Warchol

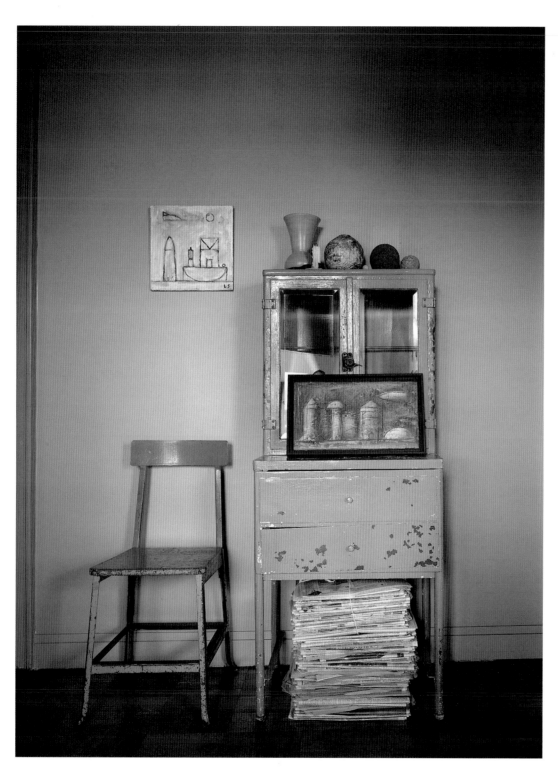

Left: Many pieces of furniture in the apartment have been recycled. In the living room are an optometrist's cabinet and a garment worker's chair.

Right: Also in the living room are a desk, chairs, and lighting designed by the architect.

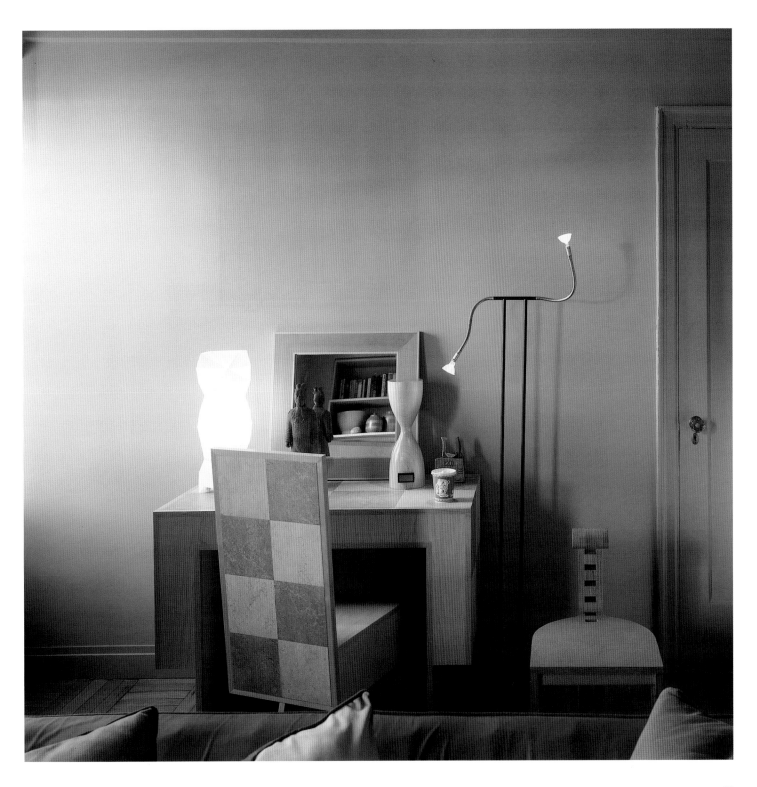

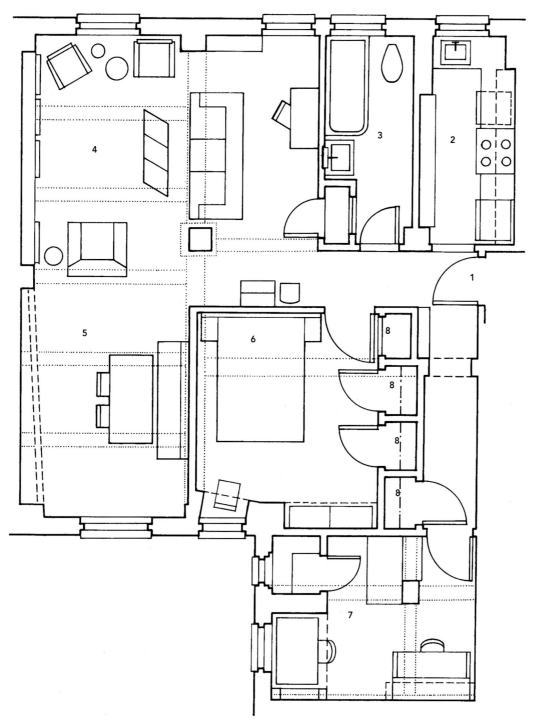

1. Entry 5. Dining Area

2. Kitchen 6. Bedroom

3. Bath 7. Office

4. Living Area 8. Closets

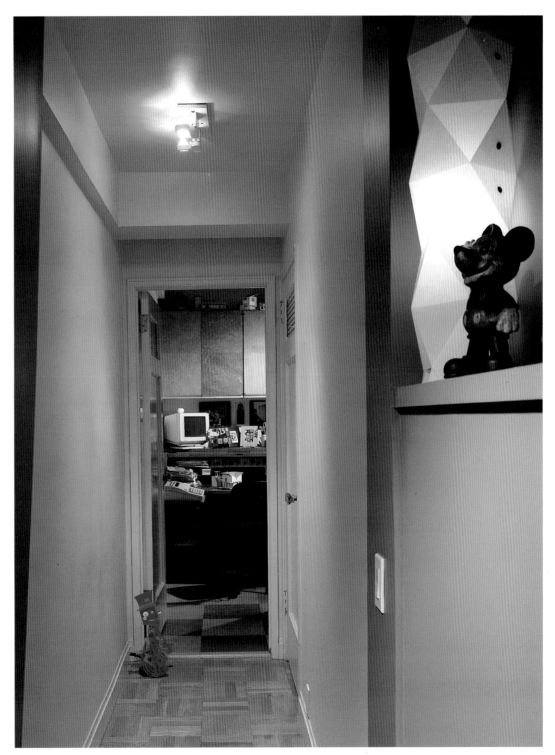

Above: A detail of the office counter covered with recycled plastic. The "Corian" lamp was designed by the architect and a concrete and fiberglass "Planet" lamp was designed by Don Ruddy.

Right: A view of the new hallway to the office, which was created by combining the original studio's kitchen and bath. The old kitchen cabinets were resurfaced with linoleum and now provide storage. The shelf at right suggests an entry vestibule.

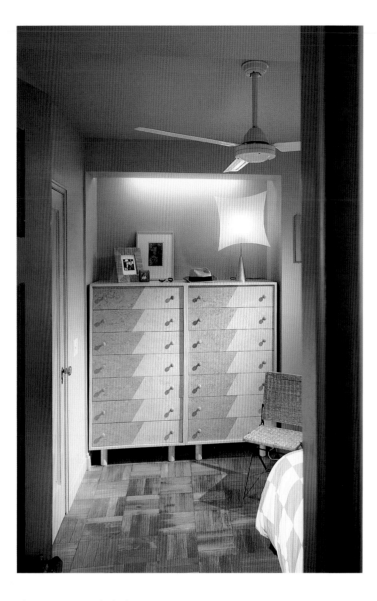

Above: Dressers in the bedroom are set into alcoves to maximize storage and reduce visual clutter. The dressers and lamp were designed by the architect.

Right: The architect painted trim, ceilings, and walls a deep, strong blue to blur the edges of the room, making it appear larger. He also designed the wall-hung headboard and the light fixtures.

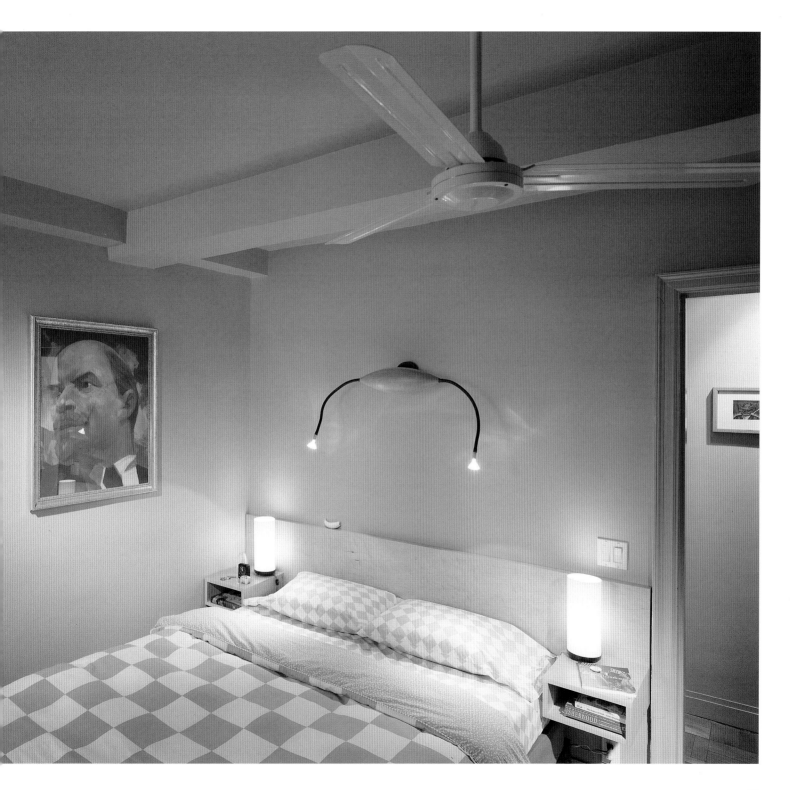

SOHO SPACE STATION

Robin Elmslie Osler

The challenge was to combine two tiny apartments into a 700-square-foot open space that would function as both a living and work environment. The client, a new media expert fascinated with space travel, asked the architect to take her design inspiration from two of his favorite films, 2001 and The Day the Earth Stood Still. The result is as high-tech as a space station where everything has its place in order to keep the "mission" running smoothly.

Space-age finishes and materials were used throughout the apartment, including brushed steel, special acrylic panels, vinyl sheeting for the floors, and rubber for the curtains.

The dominant piece of furniture, a dining table designed by architect Norman Foster, completes the space station motif, resembling nothing other than a lunar module touching down on the gray surface of the moon.

Photography: John M. Hall

BIG IDEA:

While the owner of the apartment wanted a simple, open space, he also wanted the apartment to have distinct areas for sleeping, working, and entertaining. The architect's solution was to divide the space in two using high-tech curtains suspended from ceiling tracks and concealed in opposing brushed steel wall units. One curtain is black and is used to separate the office from the sleeping area at night. The other curtain is a gray rubber insect screen that divides the living/dining area from the living/bedroom area. The curtains extend floor to ceiling and are drawn manually.

Right: From the entrance, one has a panoramic view of much of the apartment. The dining area is in the foreground, and separated by a gray rubber insect screen is the living area. The office area is to the right. The floor is covered in LonPlate, a vinyl sheeting that simulates metal flooring.

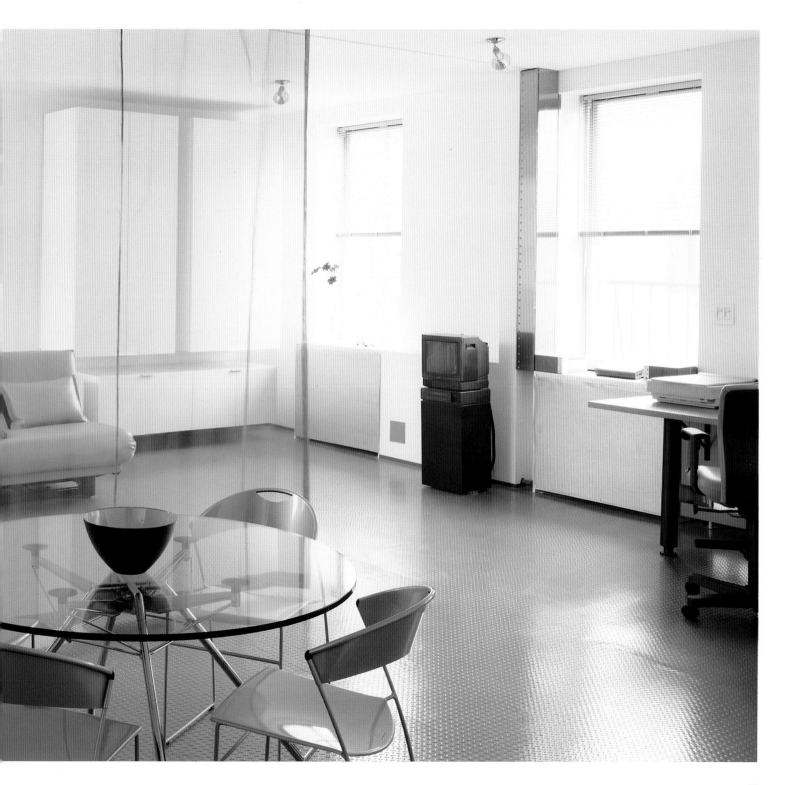

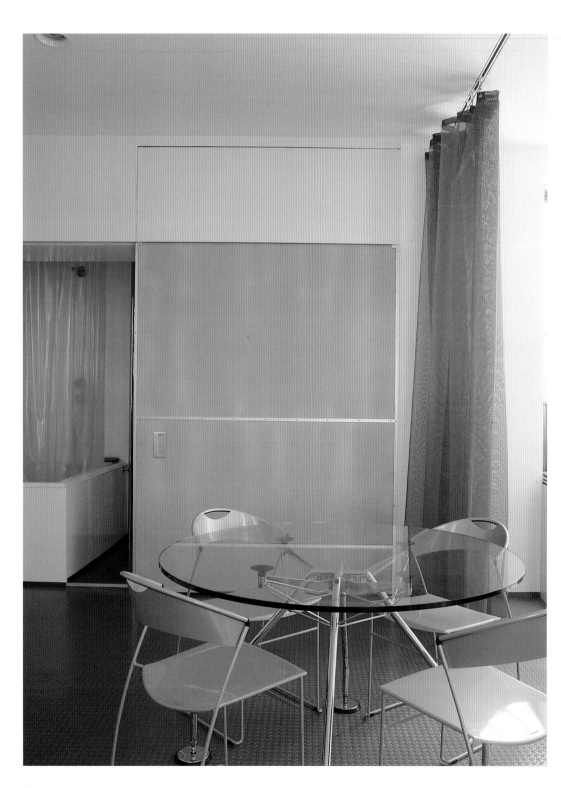

Left: A view of the bathroom with a sliding door constructed of stainless steel mesh. The dining table was designed by Norman Foster.

Right: Views of the bathroom. The walls are panels of Lumasite, an acrylic used in manufacturing highway signs.

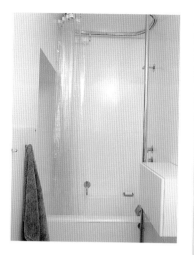

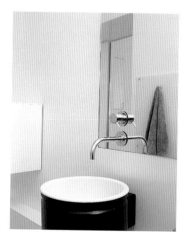

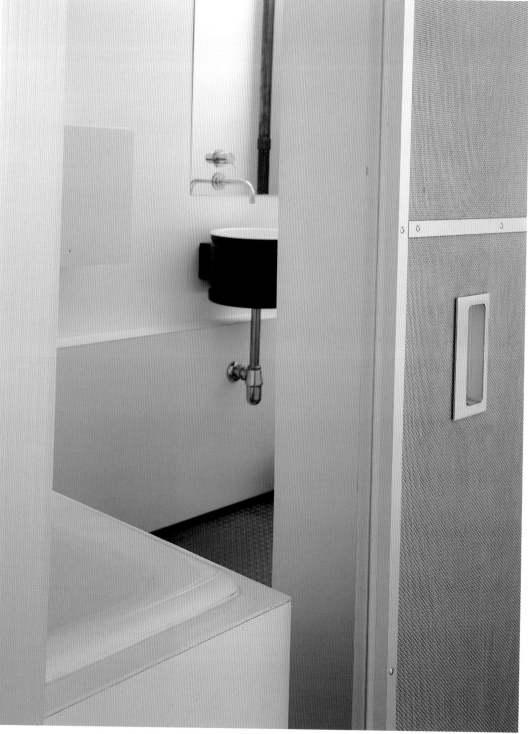

FLOOR PLAN

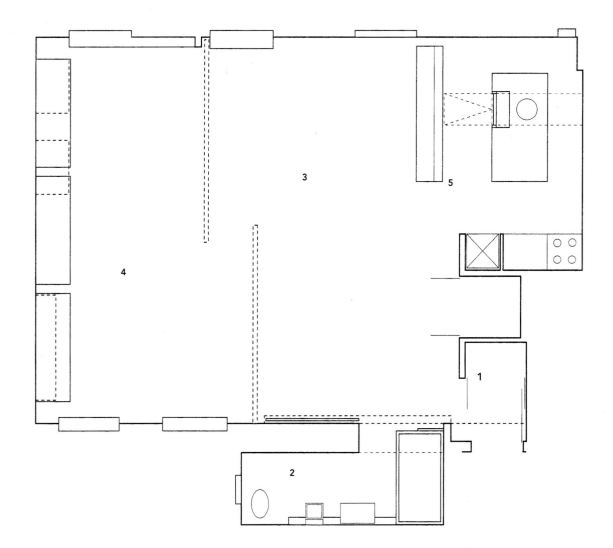

1. Entry

2. Bath

3. Living/Office

4. Living/Sleeping

5. Kitchen

Right: Before and during construction. The slickness of the apartment is all the more remarkable considering that the original condition of the space was poor and allowances had to be made for uneven floors and bulging walls.

Photography: Robin Elmslie Osler

 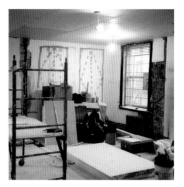

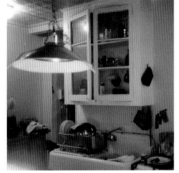 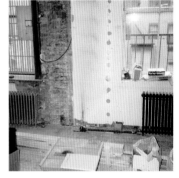

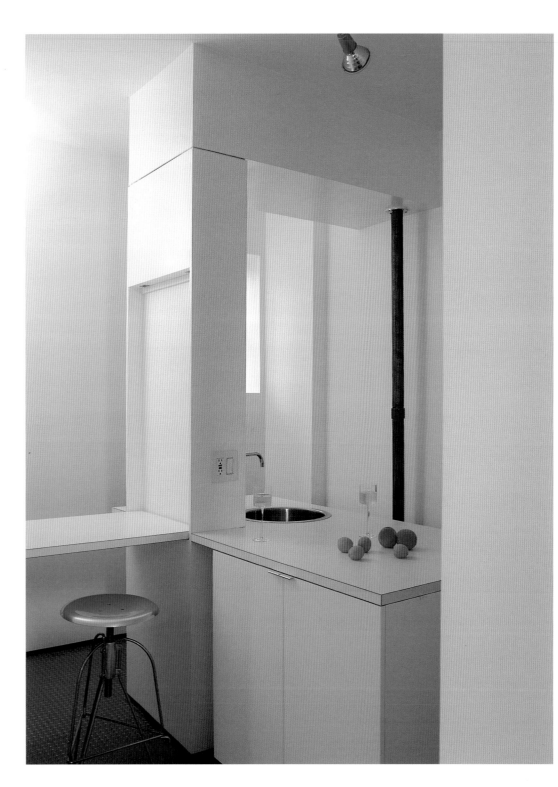

Left and Right: Thoughtful design continues in the kitchen, where the paint has been stripped from the refrigerator door and replaced with a clear polyurethane coating. Past the dining room table is the brushed steel box which contains the gray rubber room divider.

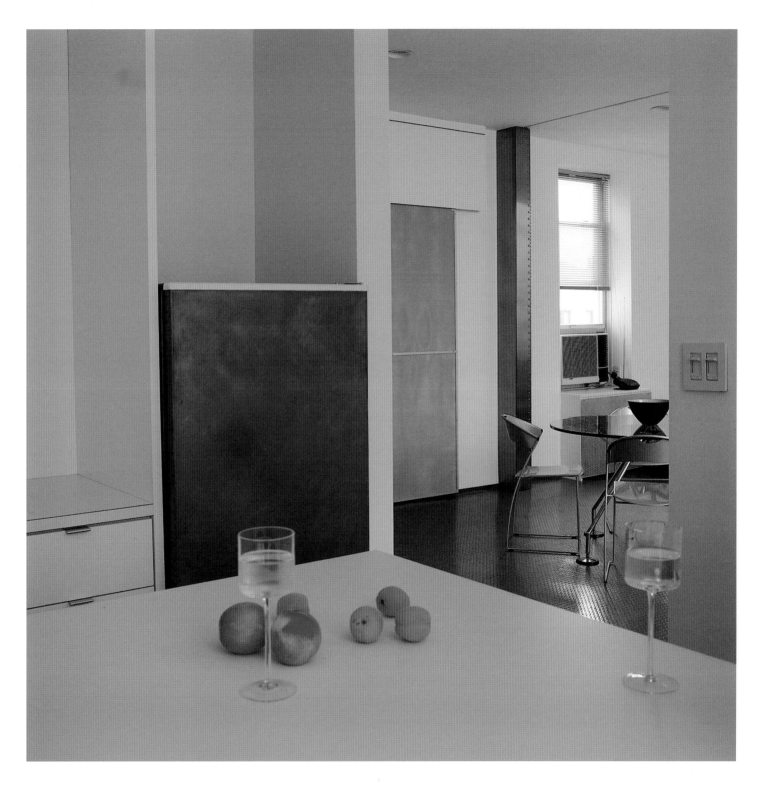

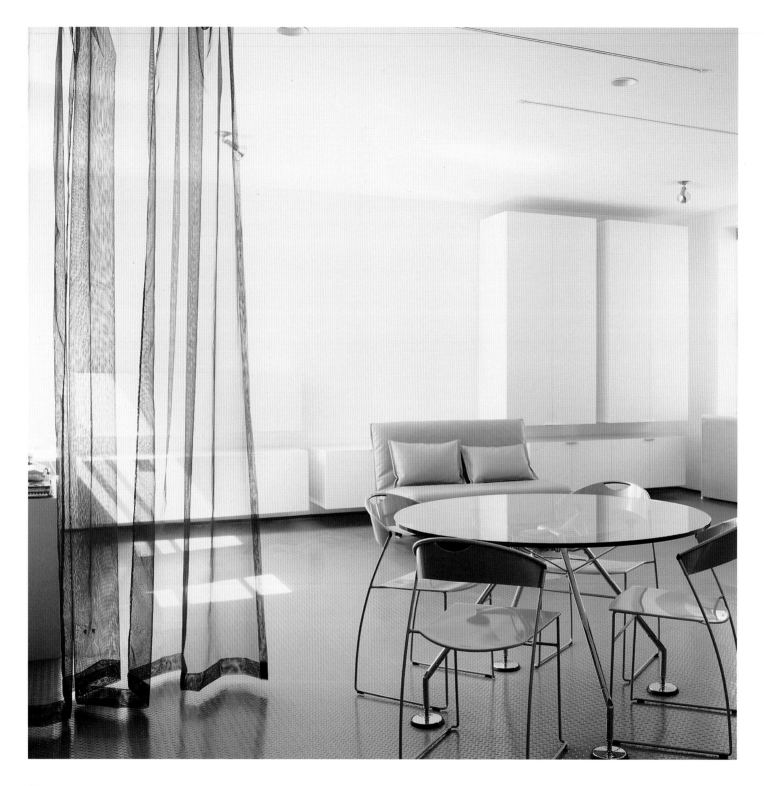

ARCHITECTURAL ASSEMBLY

Frederick Biehle & Erika Hinrichs
Via Architecture Studio

The renovation of this 650-square-foot penthouse resulted in the removal of all of the interior walls to create a loft-like space to house the owner's contemporary furniture and art collection. The apartment faces south and west and surrounds a large terrace. A smaller terrace is adjacent to the kitchen. The architects used raw, industrial materials to enhance the feeling of being in a loft. The kitchen is equipped with limestone counters and cabinets made of stainless steel angle frames with glass shelving. The walls are raw browncoat plaster.

BIG IDEA: The shower/bathroom is the heart and soul of this apartment. It is located along a raised platform hallway that separates the bedroom from the living room and kitchen area. Essentially it is an over-sized shower room lined on three sides with 3 1/2-foot-square limestone panels. Water from the shower drains into open joints in the limestone on the floor to a subfloor below. The entrance wall is constructed of sandblasted glass which extends from the kitchen at one end to the bedroom at the other. When showering, the bathroom door, which is directly across the corridor from the terrace, can be left open for an al fresco bathing experience with a panoramic view of lower Manhattan. At night, the glass wall, which is framed in raw stainless steel, glows like a lantern, illuminating the interior spaces.

Left: The living room opens onto the terrace. Past the fireplace is the kitchen and down the corridor is the sandblasted glass wall of the bathroom. The floors are poured concrete with maple framing. The painting over the mantel is "Portrait" by Janice Krasnow.

Photography: Lynn Massimo

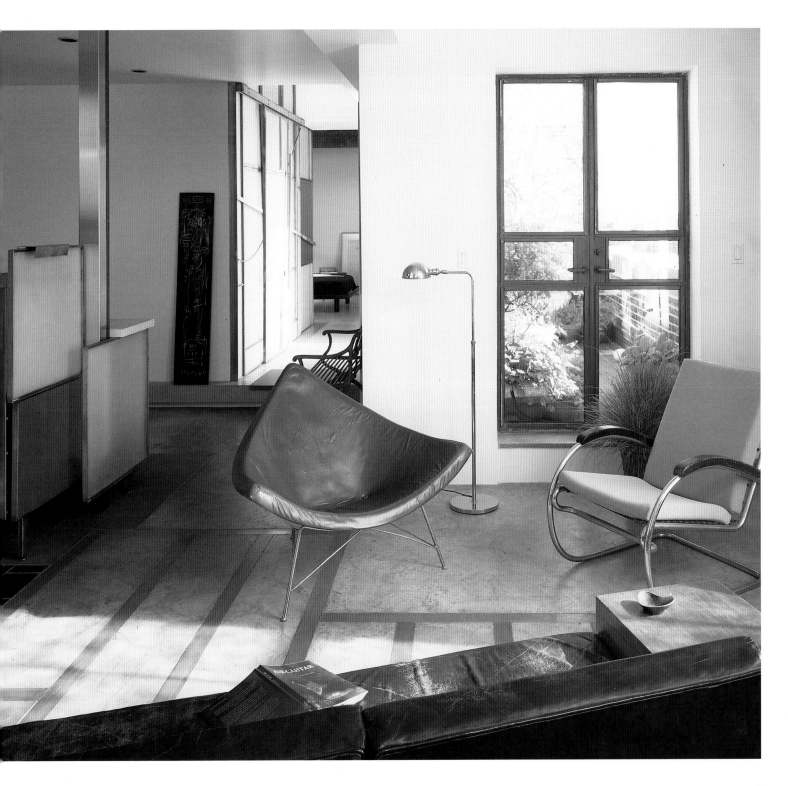

Left: Mid-century furniture graces the living room, including a couch and Coconut chair by George Nelson and a Kern Weber lounge chair. The painting on the left is "Five Deaths" by Andy Warhol. The photograph on the far wall is "The Sorceress" by C. Brancusi.

Right: Light is a primary inhabitant of this apartment. Facing south and west, the space constantly changes during the day as the light moves across the room.

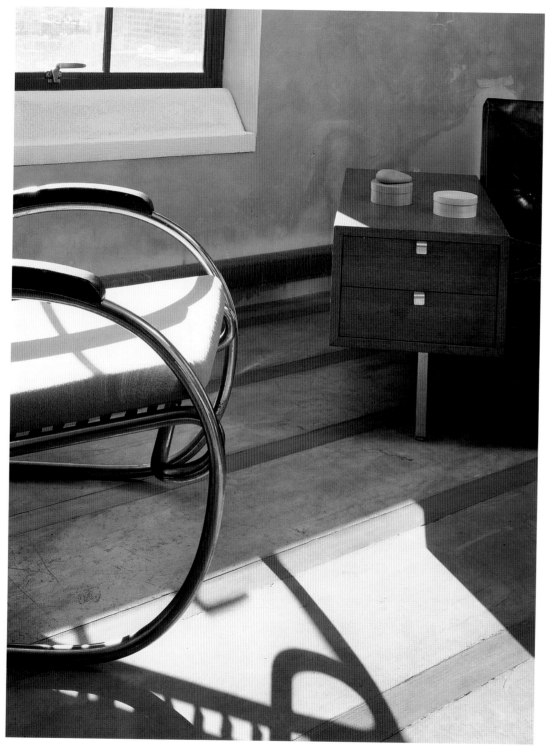

FLOOR PLAN

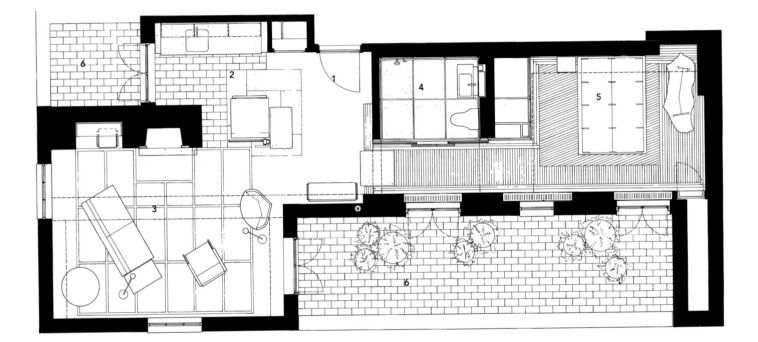

1. Entry
2. Kitchen
3. Living Area
4. Bathroom
5. Bedroom
6. Terrace

Right: The kitchen, which is open to the living room, is a masterpiece of industrial design, with limestone counters, stainless steel and glass cabinets, and stainless steel appliances. The glass doors open onto a small terrace. The terra-cotta floor tiles were salvaged from the roof terrace of Andy Warhol's last factory studio.

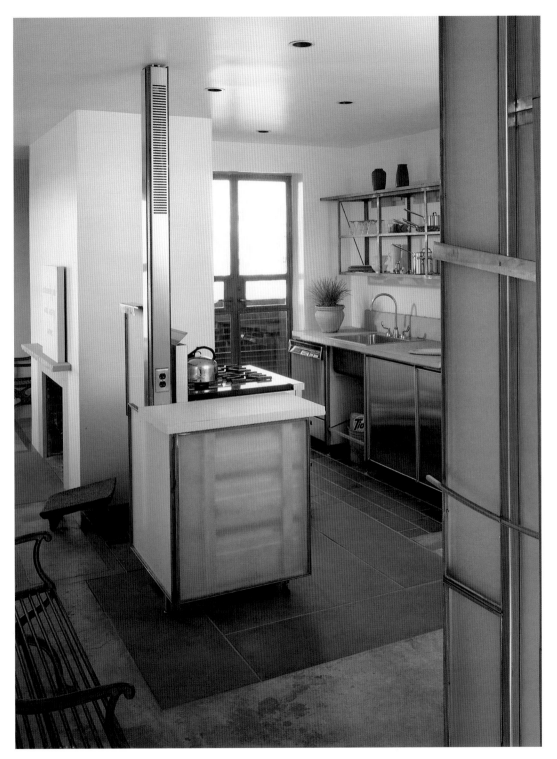

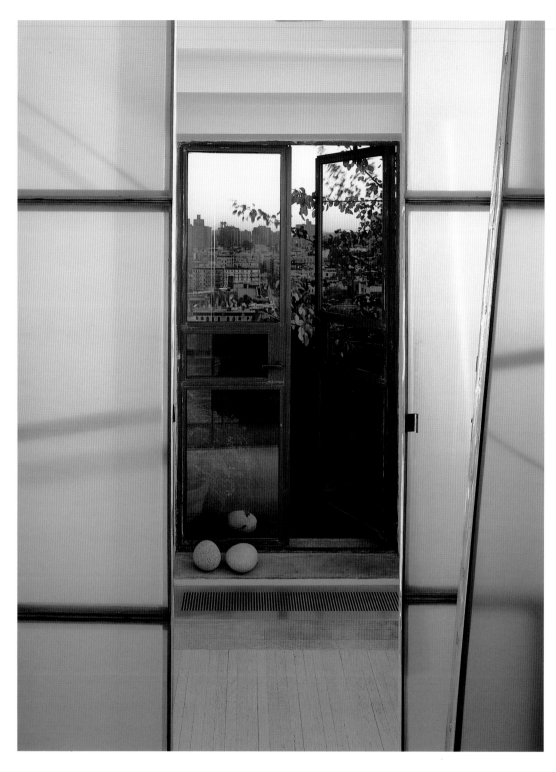

Left: From the bath looking across the corridor and terrace to the Manhattan skyline.

Below: A detail at the entrance to the bathroom showing juxtaposition of the bleached and unbleached oak flooring of the raised corridor with the limestone floor of the bathroom.

Photograph: Frederick Biehle

Right: The sandblasted glass wall of the bathroom, which extends from one end of the corridor to the other. Inside, the walls of the bathroom are covered with large, square limestone panels.

Below: A detail showing the bluestone and oak flooring in the corridor.

Photograph: Frederick Biehle

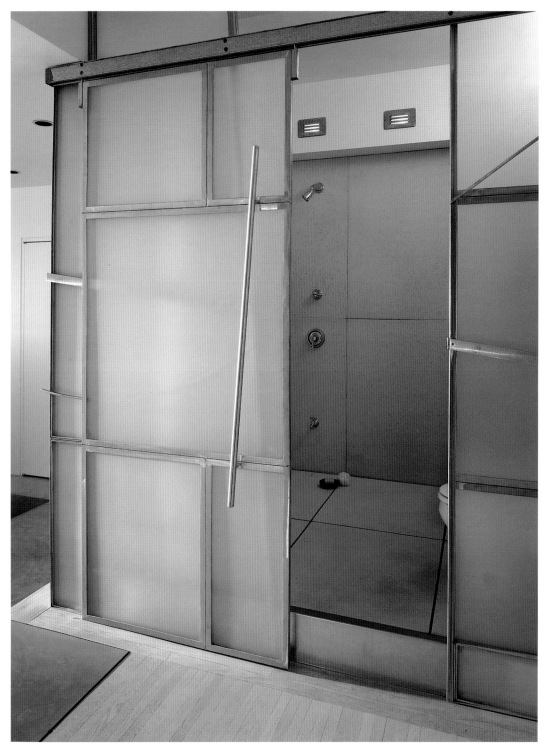

FOLLOW THE WALL

Stamberg Aferiat Architecture

In its original state, this apartment held few charms for its owners, so they decided to have it gutted. They requested that the architect create a more dramatic entry as well as make the apartment feel larger than its 880 square feet. They also wanted an unusual fireplace, a powder room, a modern kitchen, and as much storage space as possible. Where there had been a small closet, a dramatic curved powder room was added. The dining room was opened up to the foyer, so that now they both appear bigger. To create a larger kitchen, space was borrowed from bedroom closets. Conversely, to improve the bedroom closets, space was borrowed from the old kitchen. This trade of space benefited both the new kitchen and closets.

Above: The fireplace mantel is crafted of a gun-blued, hand-ground steel plate attached to the wall with galvanized steel and brass fasteners.

Right: The sculpted wall runs from the entrance foyer and terminates at the mid-point of the living room. In addition to clarifying circulation, it conceals several odd bumps and jogs which made the original space appear clumsy.

Photography: Paul Warchol

BIG IDEA:

A detached, sculpted wall was added to clarify circulation from the entry foyer to the living room and back to the dining room, keeping the bedroom a "private" area. Both the wall and the powder room are detailed to read as objects inserted into the space. To make the living room feel larger, the wall is sloped into a forced perspective. Along the top is concealed incandescent cove lighting, discreetly illuminating the path from the entry, past the dining room and into the living room.

RENOVATION PLAN

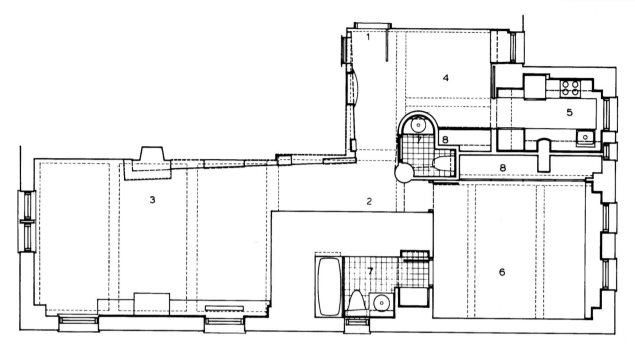

1. Entry 5. Kitchen
2. Foyer 6. Bedroom
3. Living Room 7. Bath
4. Dining Room 8. Closet

ORIGINAL PLAN

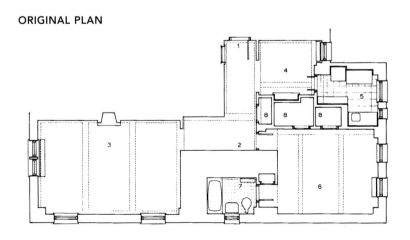

AXONOMETRIC

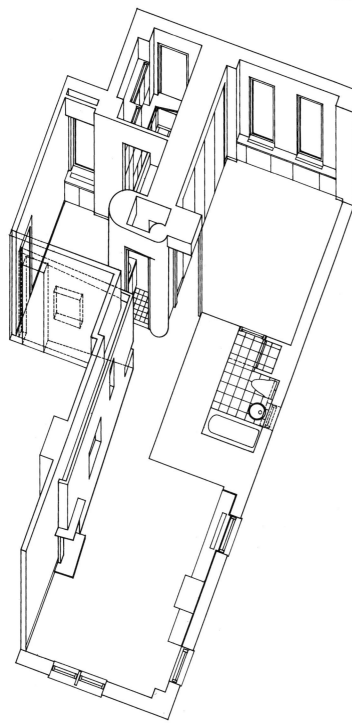

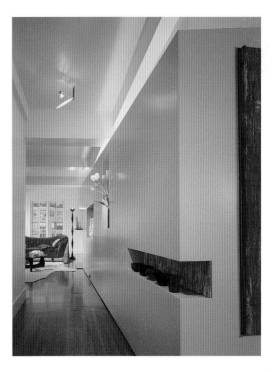

Below: The wall as seen from the entry foyer to the living room. The cove lighting on top of the wall leads one's eye along the path.

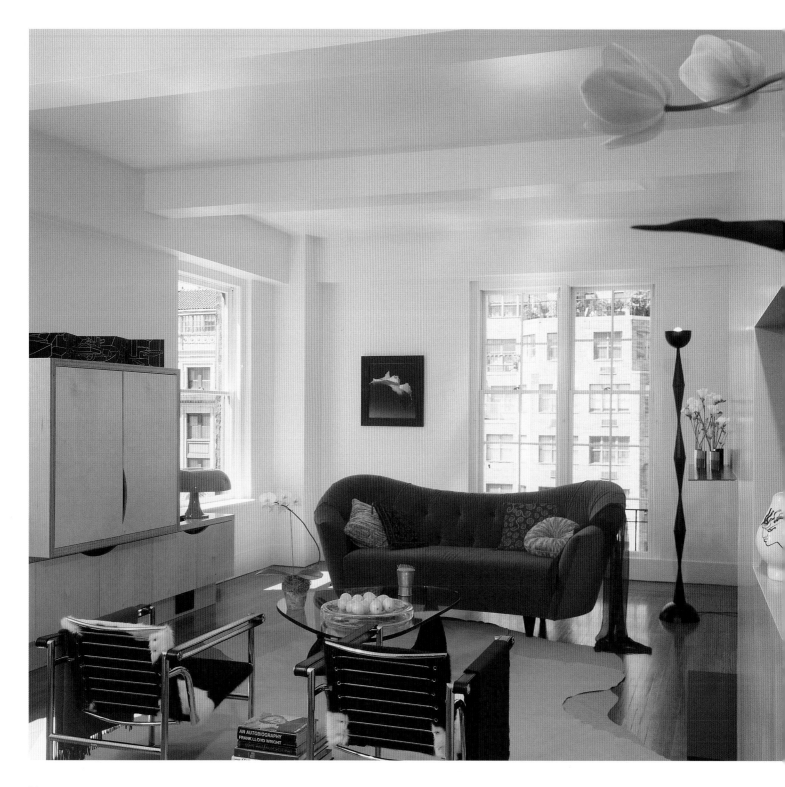

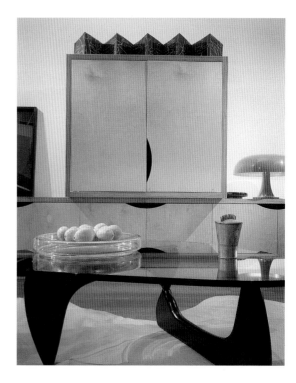

Left: A view along the angled wall to the living room. The walls of the apartment were painted in very strong shades of green, in contrast to the pale green of the original apartment.

Right Top: The Noguchi table is by Herman Miller.

Right Bottom: A detail of one of the niches in the angled wall.

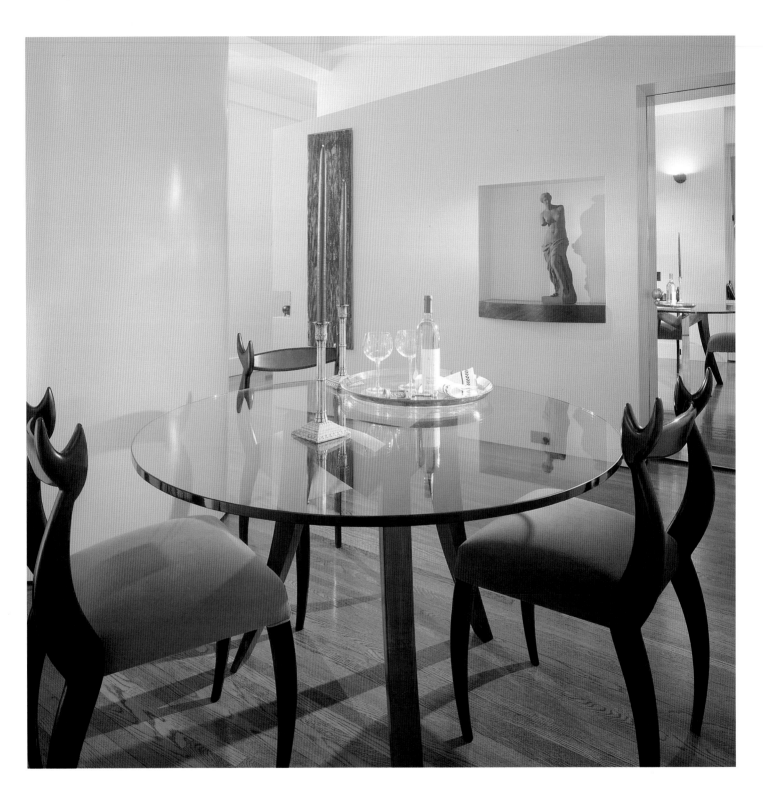

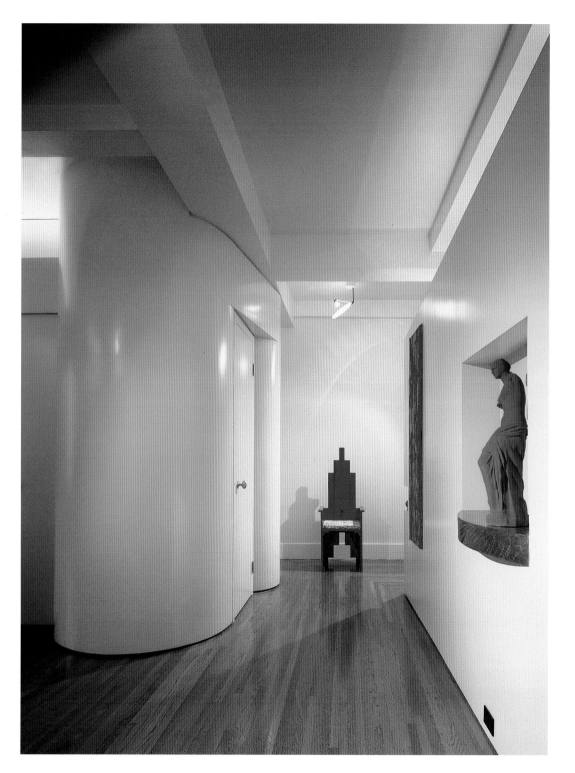

Left: A view of the dining area looking toward the entrance foyer.

Right: The curved volume encloses the new powder room, originally a small closet.

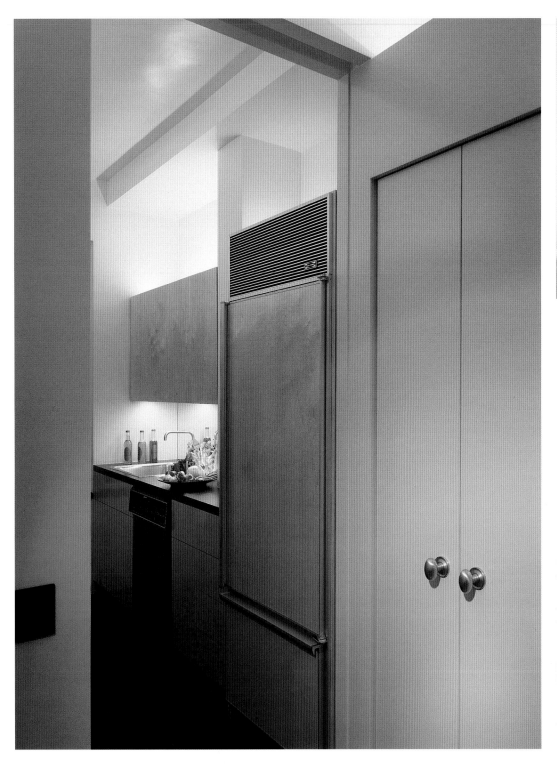

Left: To create a larger kitchen, space was borrowed from bedroom closets.

Above: A view from the kitchen to the dining area and entrance foyer.

Far Right: Industrial materials and simple black and white tiles are used in the bathroom.

Right: The round stainless steel sink fits compactly in the curved wall of the power room.

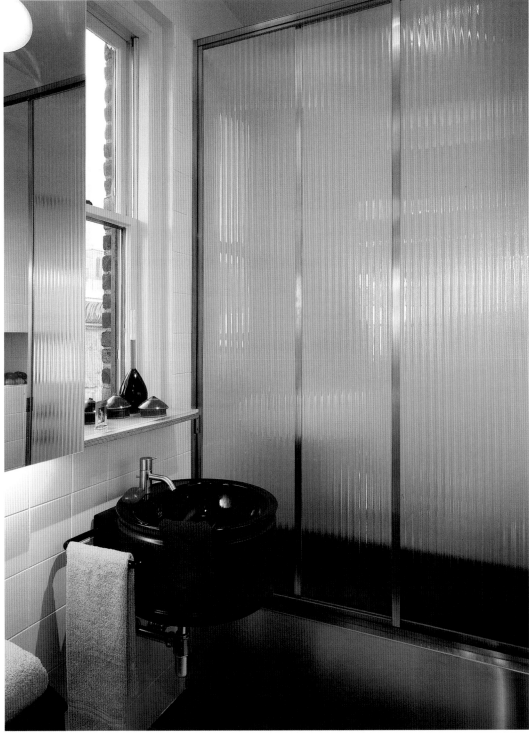

BENEATH THE SURFACE

Hiroshi Naito

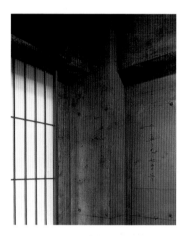

The owner of this apartment in Tokyo lives in another unit in the same building. She is a magazine editor who does a lot of entertaining and uses this apartment for that purpose as well as to accommodate overnight guests. Although measuring less than 400 square feet, this apartment was originally two bedrooms. For the renovation, all the original walls and partitions were removed, creating one large living/sleeping space, a kitchen large enough to accommodate a dining table, and a bathroom.

Above: The exposed concrete walls with the original construction notation and measurements.

Right: View of the living/bedroom area with the entrance to the space on the left. Insulation boards covered with glass cloth were attached to the ceiling to help define the space while absorbing sound.

Photography: Kazunori Hiruta

BIG IDEA: The most striking feature of this apartment are its walls. Made of poured-in-place concrete, they had been covered with plasterboard. Once stripped bare, the architect discovered original construction markings on the concrete. These markings combined with exposed plumbing and electrical conduits painted black give the space a raw, unresolved appearance. This is in sharp contrast to the soft, white sheets of fiber glass bolted to the ceiling to both define the space and to absorb sound.

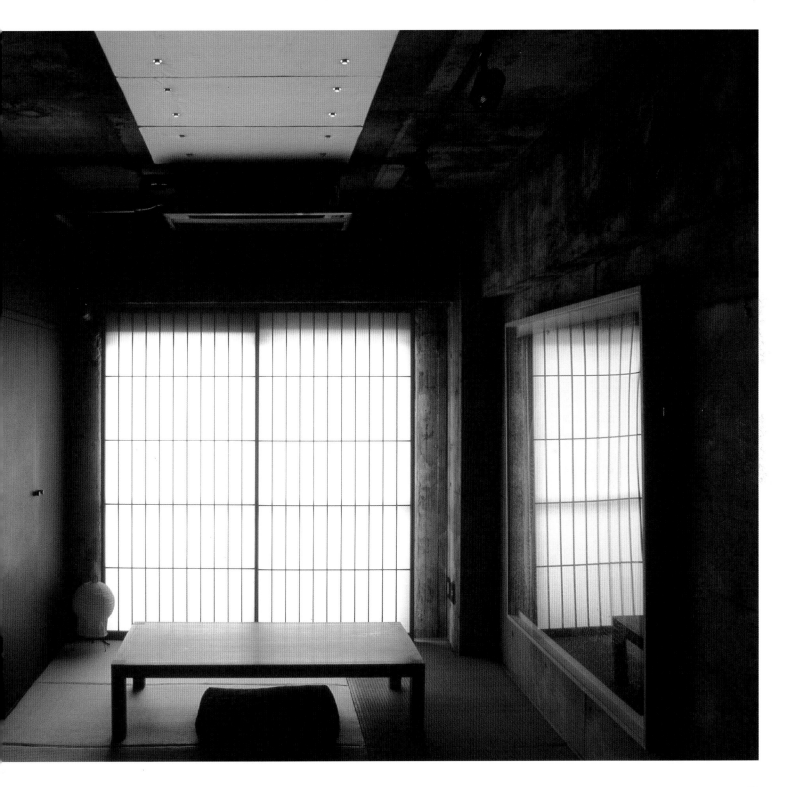

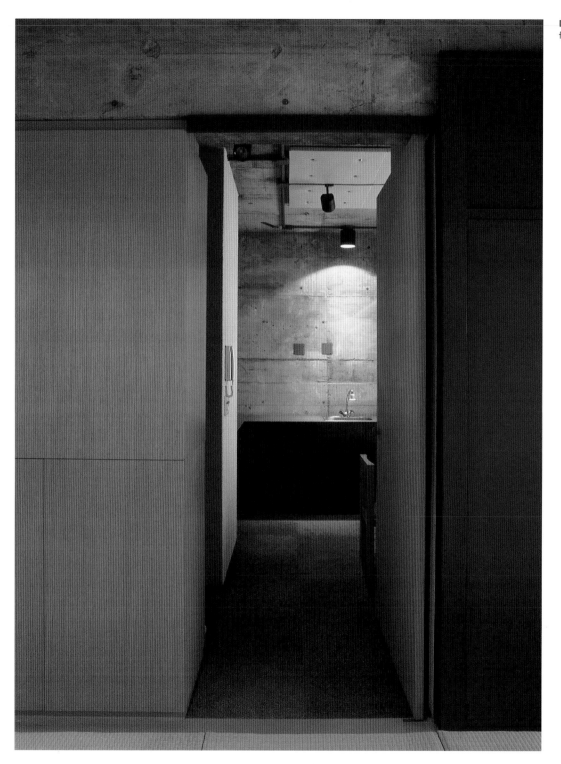

Left: The kitchen/dining area as seen from the living area.

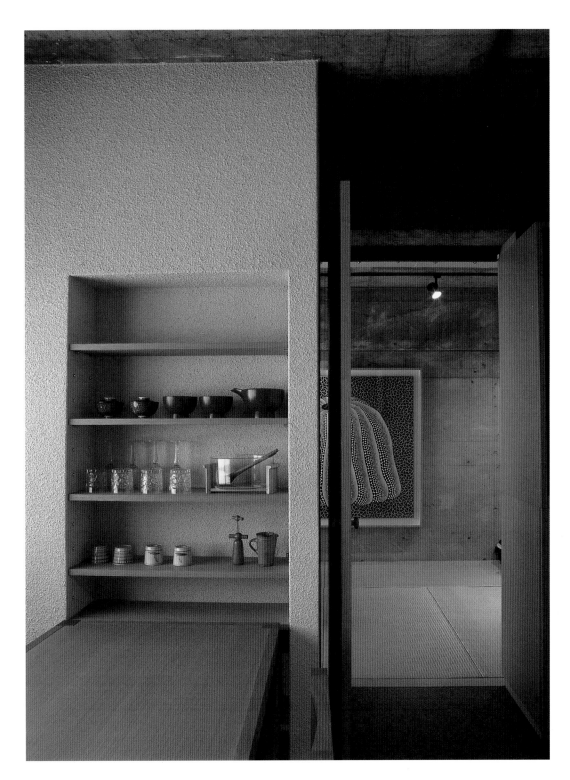

FLOOR PLAN

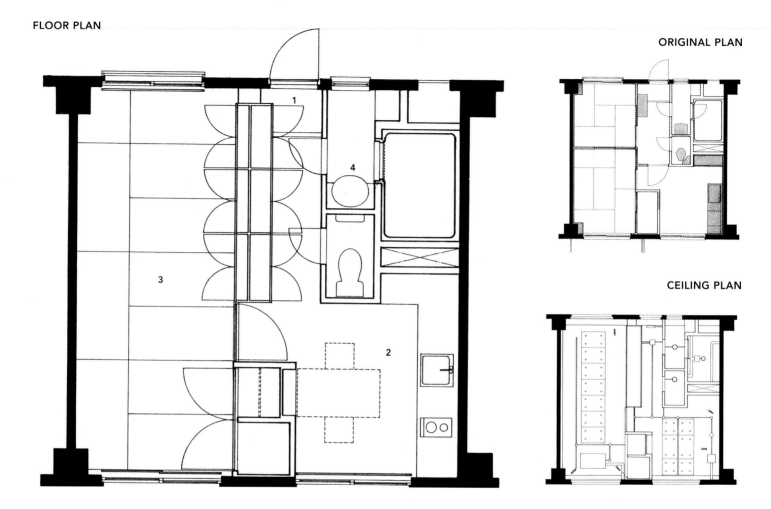

1

4

3

2

ORIGINAL PLAN

CEILING PLAN

CONCEPTUAL SKETCH

1. Entry

2. Kitchen/Dining

3. Living/Sleeping

4. Bathroom

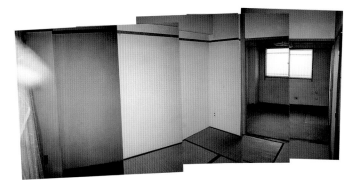

AXONOMETRIC

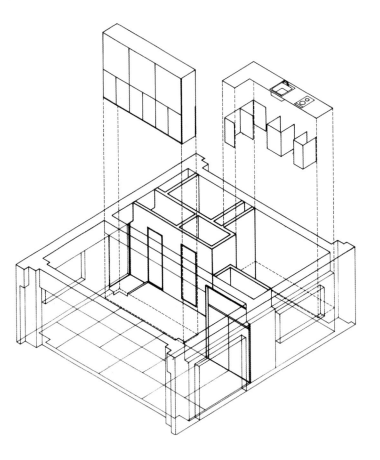

Above: Photo collages of the apartment
before renovations.

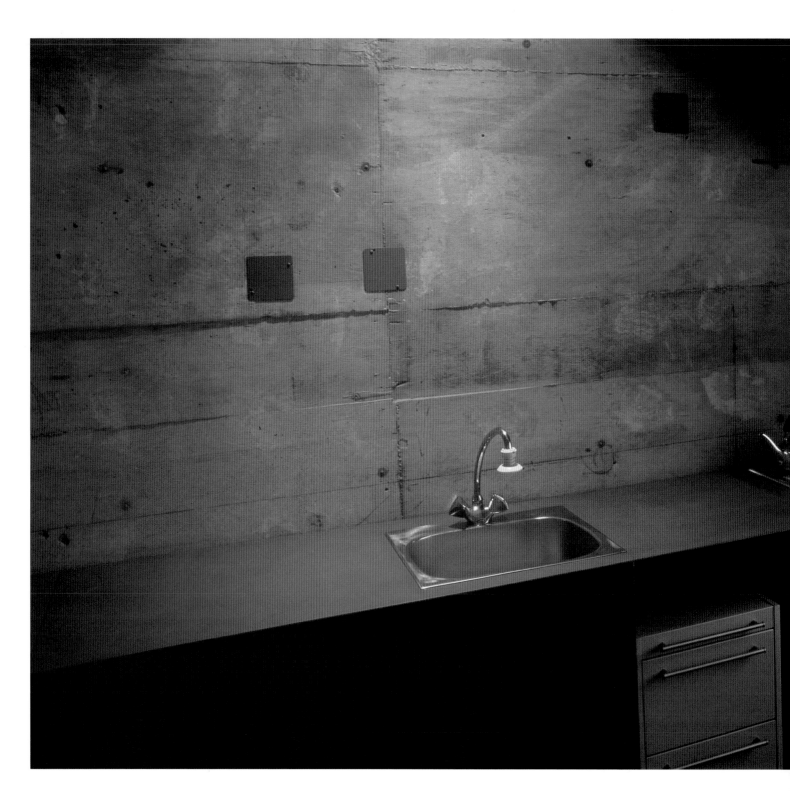

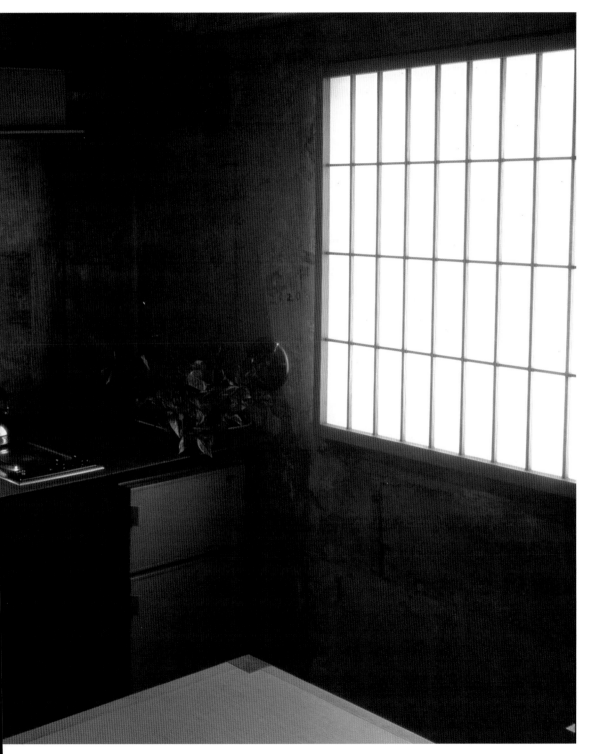

Left: Slate was chosen for the kitchen counters to match the stark, monochromatic walls and ceiling.

FULLY BOOKED

Richard Lavenstein

The renovation program for this 400-square-foot apartment was complex since the owner, a book editor, had several programmatic requirements, including extensive shelving for books and collectables. An office area, a formal dining space, room for a large television, and an improved kitchen were also on the wish list.

Most of all, when finished, the design for the apartment was expected to accommodate these requirements and all of the books and objects without the appearance of excessive clutter.

The architects chose all the furnishings, fabrics, and carpets. The colors are muted, almost monochromatic, unifying the apartment, leaving the books and collectables to provide color and visual interest.

Right: A view of the living area with the office area to the left.

Following Pages: From the living area, virtually the entire apartment unfolds before the viewer's eye. The floating glass shelves allow the television to be seen from the living area. All walls were removed and replaced with thick shelving and storage.

Photography: Peter Aaron/Esto

BIG IDEA: In order to accommodate the enormous book and objet d'art display and storage requirements, all of the partition walls in the apartment were removed and replaced with thick storage and display zones. Particularly effective is the cabinet divided between the living area and the sleeping area, with floating glass shelves on the end which allow seeing the television from the living room as well as the bedroom, where it is located.

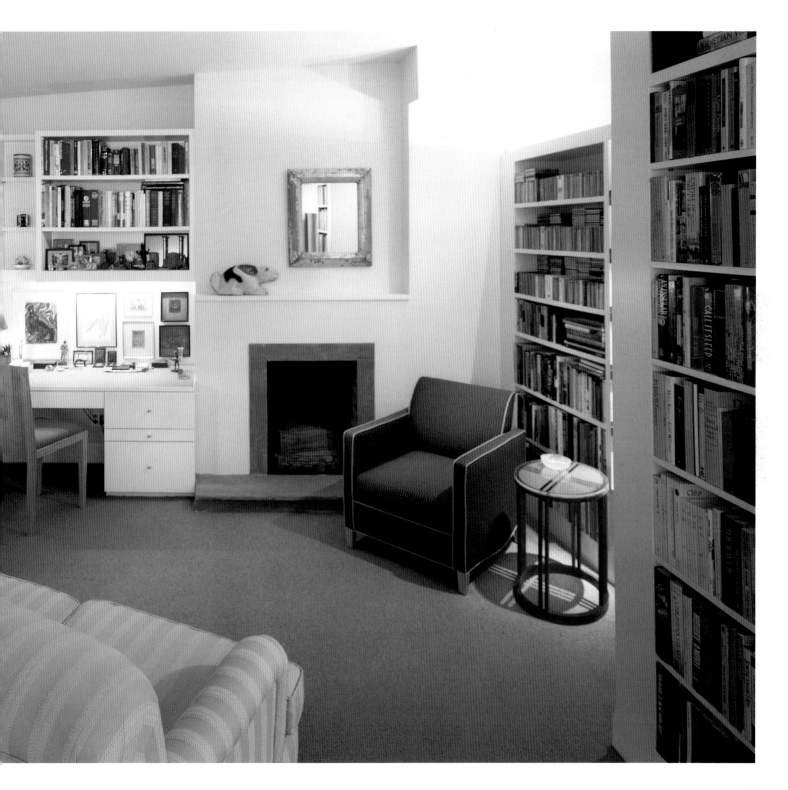

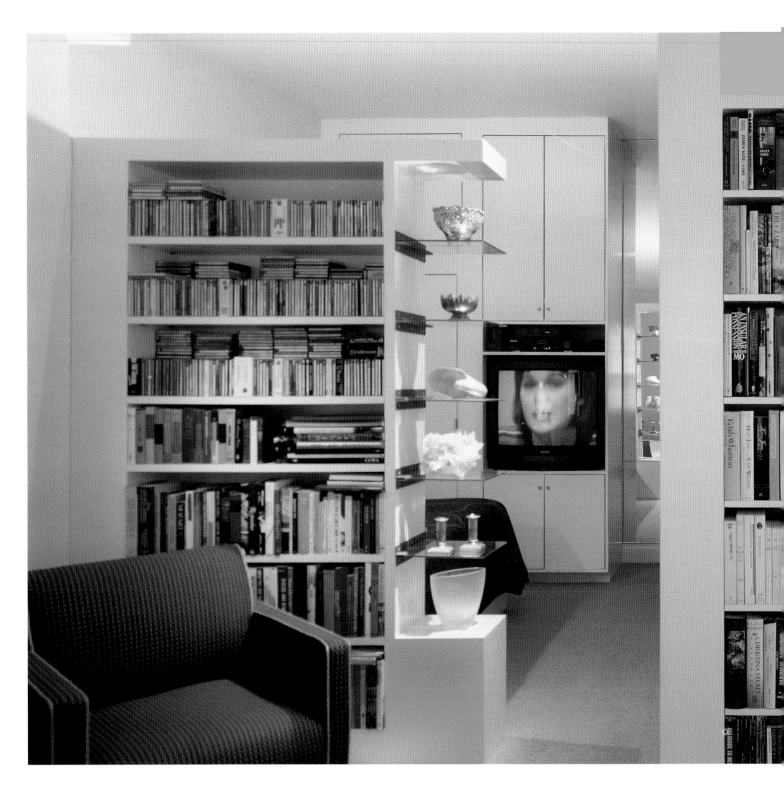

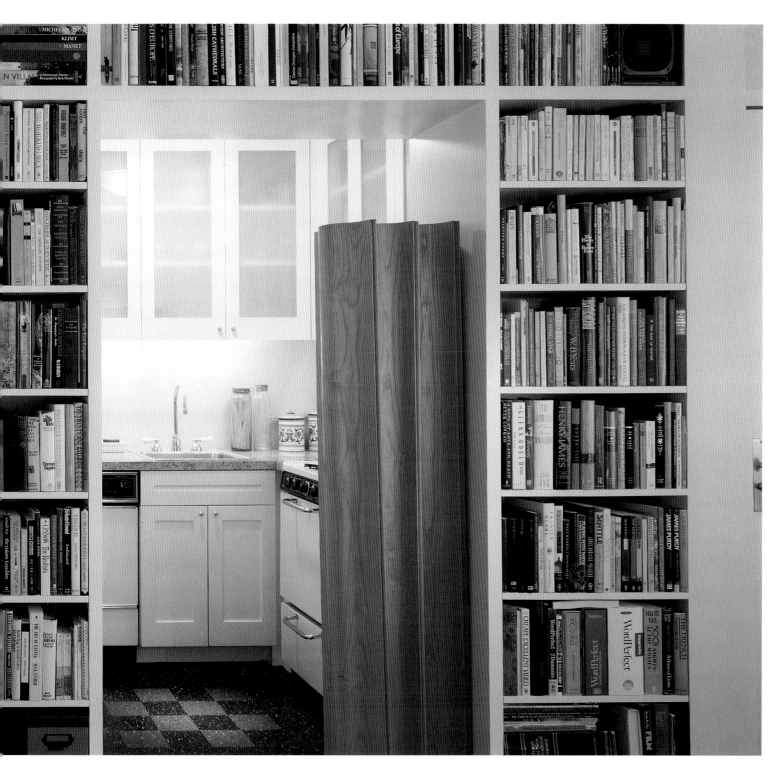

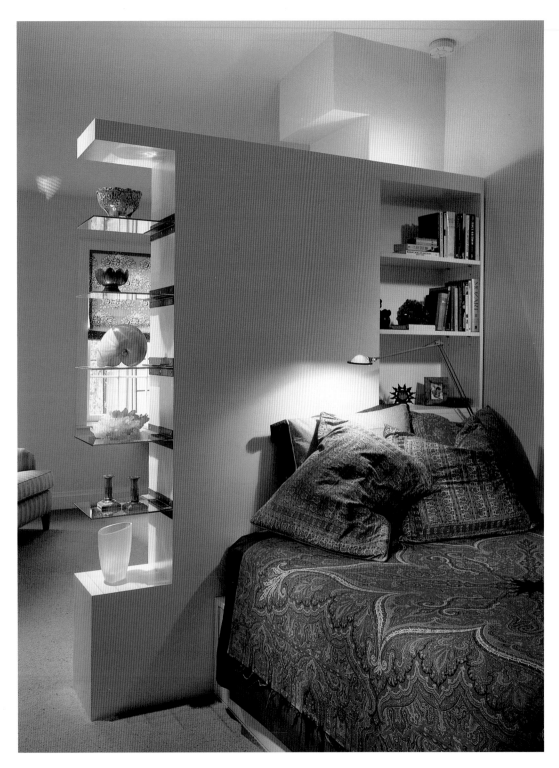

Left : Uplights are hidden in the top of the divider between the bedroom and living area, providing general illumination.

Right: The formal dining area with a built-in china closet.

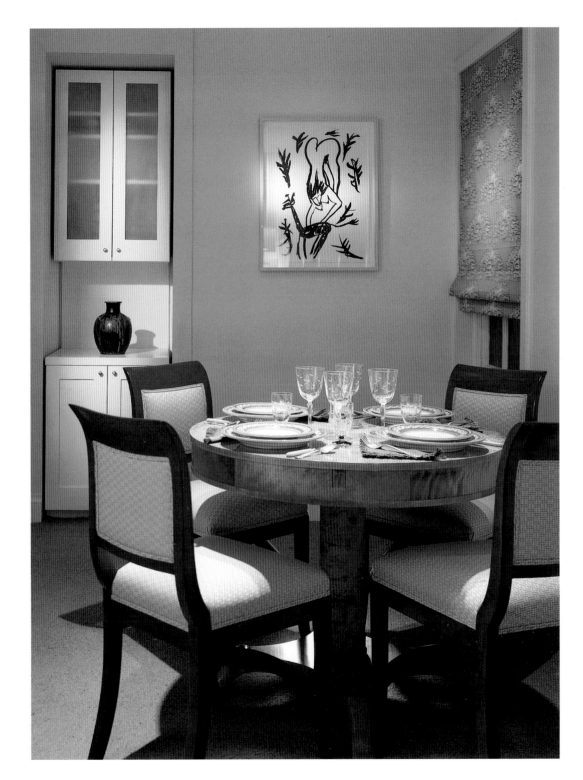

FLOOR PLAN

1. Entry 5. Living Area

2. Bath 6. Dining Area

3. Kitchen 7. Office Area

4. Bedroom

Left: The office area, with a built-in desk and fax, overlooks a beautiful courtyard.

Right: The architect designed all of the cabinetwork in the apartment. Here, sandblasted glass in the cabinet doors provide interior "windows" in the windowless kitchen.
The backsplash is made of Halian plastic laminate, which resembles stainless steel.

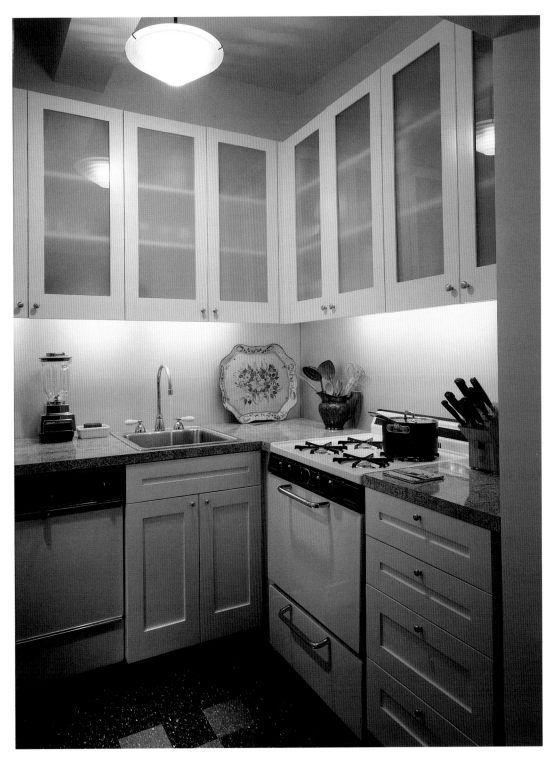

INDUSTRIAL ANGLES

Martine Seccull

BIG IDEA:

A dominant feature of this apartment is the terrace. It is made all the more so by the architect's decision to make it an integral part of the living space through the use of an overscale garage door. Since the door flips up parallel with the ceiling, the entire width of the terrace is open to the living area.. Thus the distinction between interior and exterior space is blurred. The view of the terrace is virtually unobstructed from either the kitchen or the living area of the loft. The choice of glass and galvanized steel contributes to the industrial loft effect that the architect set out to achieve.

Designed to look like a renovated industrial loft, this is actually a new apartment that the architect built for her own use. Although quite small by loft standards, it appears large and expansive because of strong architectural details, a pitched ceiling, an open floor plan, and a terrace which has been made an integral part of the design.

The apartment is bathed in light thanks to the generous use of dormer windows and a very large circular window that punctuates the living space.

An eclectic mix of materials was used in finishing the apartment ranging from stainless steel and glass to faux polar bear fur used to cover one wall in the bedroom. Dark ebony veneer cabinets contrast with white Corian countertops and stainless steel sinks in the galley kitchen.

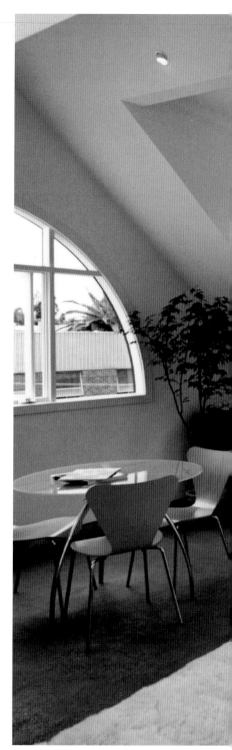

Right: A glass garage door with a galvanized steel frame gives an industrial feel to the apartment. When open, it blurs the distinction between indoor and outdoor spaces.

Photography: Jonathan Webb

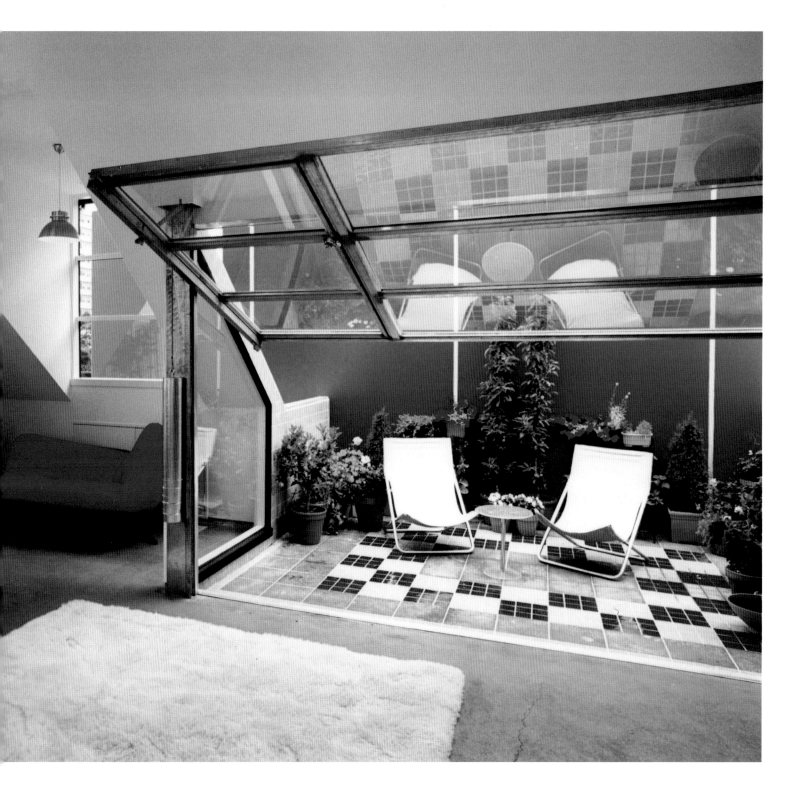

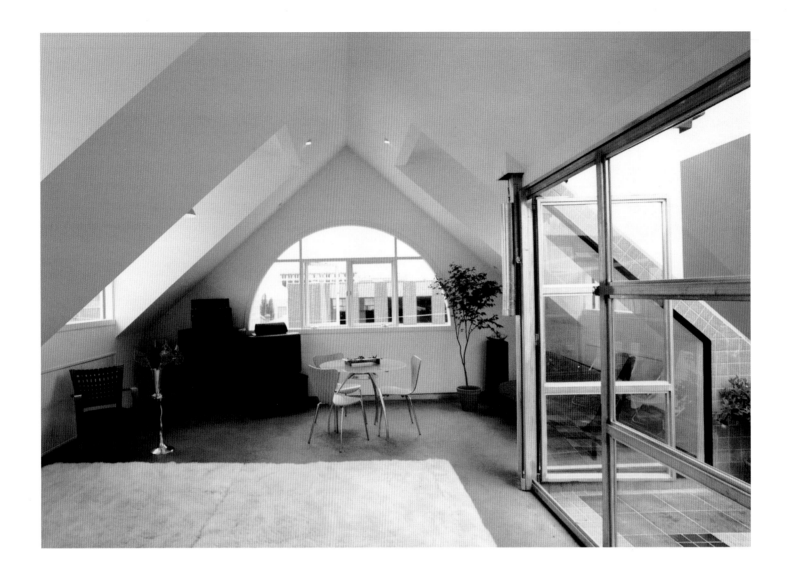

Above: Strong architectural elements are apparent throughout the apartment. The large semicircular window dominates the living area.

Right: The pitched ceiling further enhances the loft-like appearance. The open kitchen is to the right. An illuminated fish tank is carved into the wall above the sink.

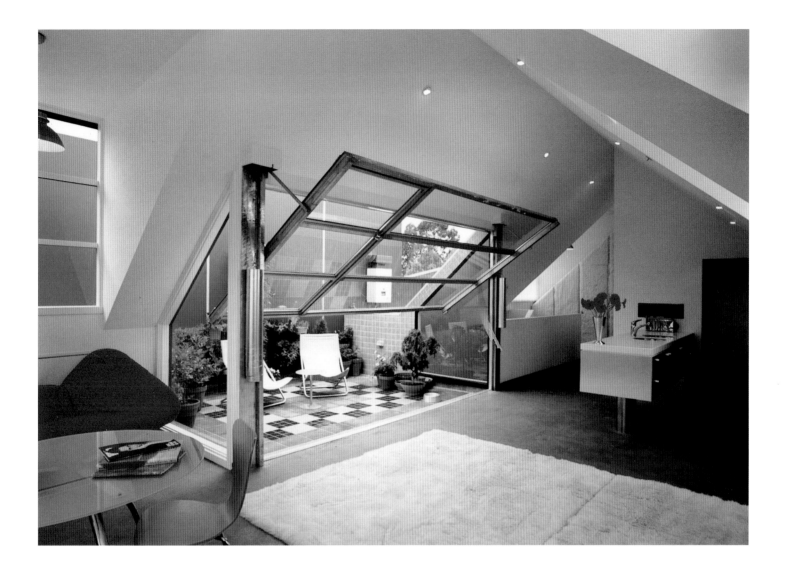

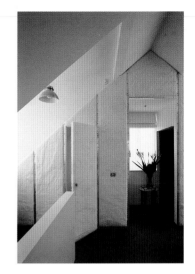

FLOOR PLAN

1. Entry 5. Bedroom

2. Kitchen 6. Living/Dining

3. Toilet 7. Terrace

4. Bath

Left: A view from the living area to the bathroom. The entrance the the apartment is to the left.

Right: The cabinets in the kitchen are constructed of ebony veneer. The counter top is made of Corian. It is supported by a stainless steel column which contains the plumbing for the sink.

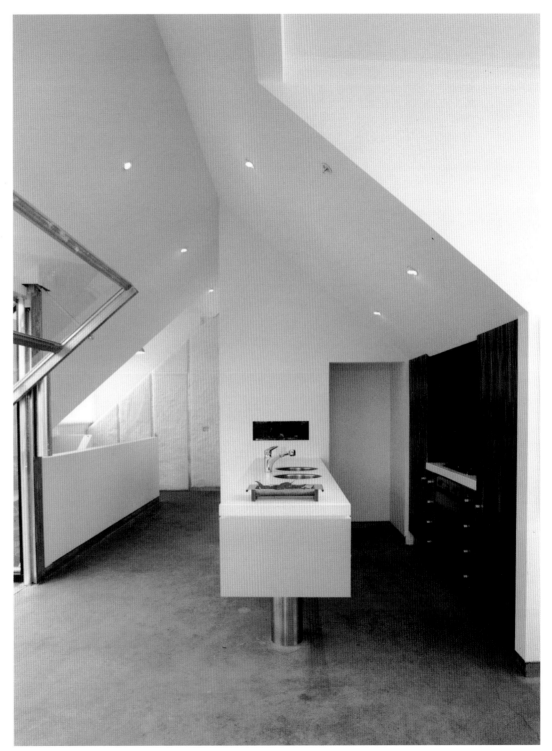

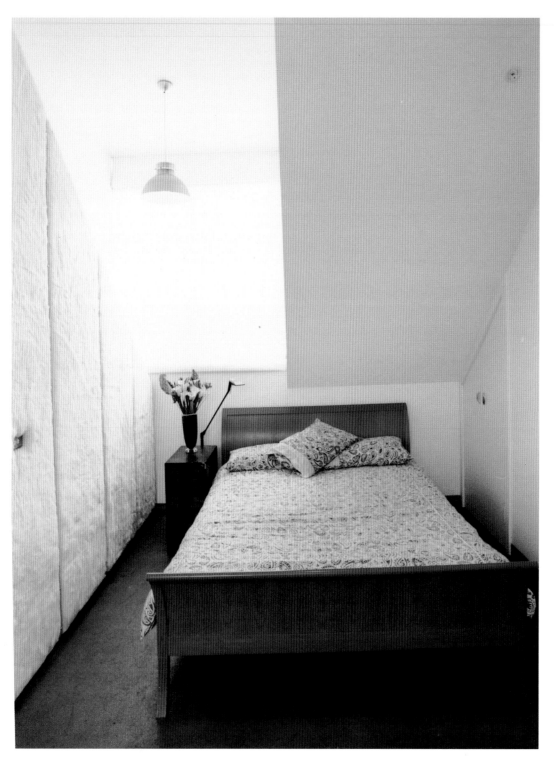

Left: In the open bedroom, the wall on the left is covered in faux polar bear fur.

Right: The shower is adjacent to the bedroom. The toilet and basin are opposite the shower.

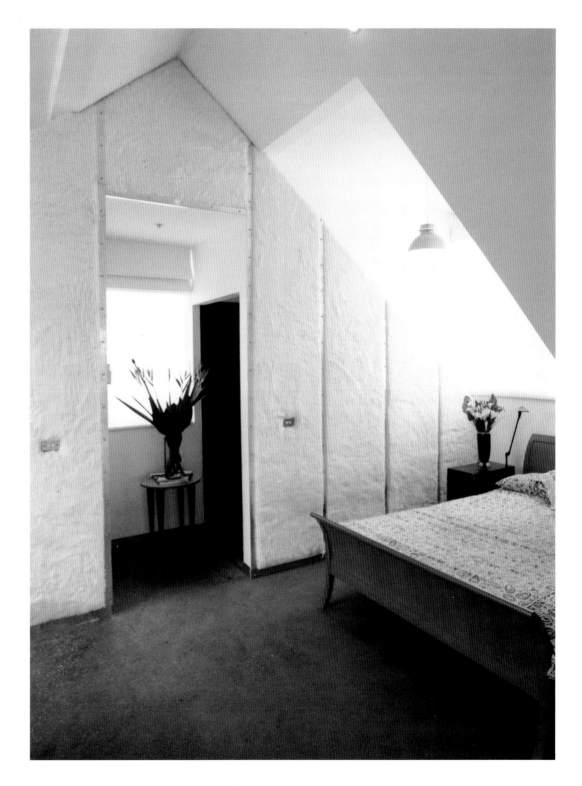

DETAILED MATERIALITY

Hanrahan & Meyers, Architects

The relatively small size of this apartment required the development of an intricate set of details and innovations in space planning in order to create a sense of large and open spaces which the owners desired. The architects used intense colors and materials that give a visual and tactile richness to the apartment. The material palette consists of cherry and birch cabinets and limestone flooring and counters.

The space was designed in the computer, through a series of rendered studies. The digital environment allowed the architects to view the space in virtual movement. As a result, there is a dynamic link between the medium of these moving sketches produced by the computer and the spatial qualities of the final design.

Above: The extraordinary attention to detail is evident in the custom-designed key holder next to the entry door.

Right: A view from the entry foyer to the dining area with the entrance to the bedroom on the right. The curved glass above the cherry cabinet separates the bedroom from the foyer, providing a visual connection between these two spaces.

Photography: Peter Aaron/Esto

BIG IDEA: The architects created a sense of movement in the apartment through the judicious selection of surface treatments. All of the walls in the apartment are finished with white plaster. The perimeter walls are a matte finish, and the wall separating the living room from the bedroom is polished and contains a movable translucent glass plane. The combination of matte and reflective surfaces establishes movement within the apartment through the push and pull between these two surfaces.

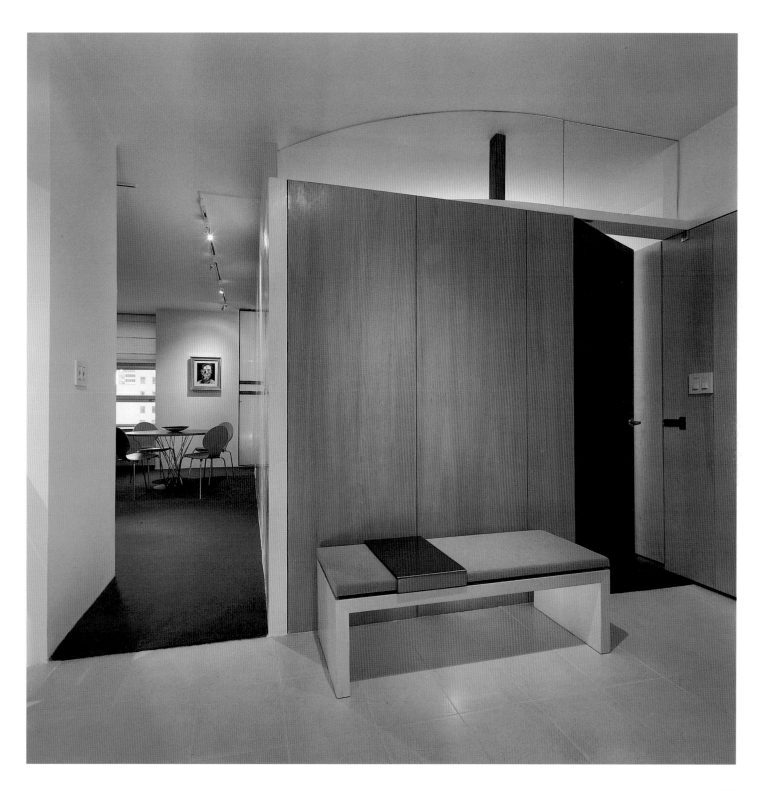

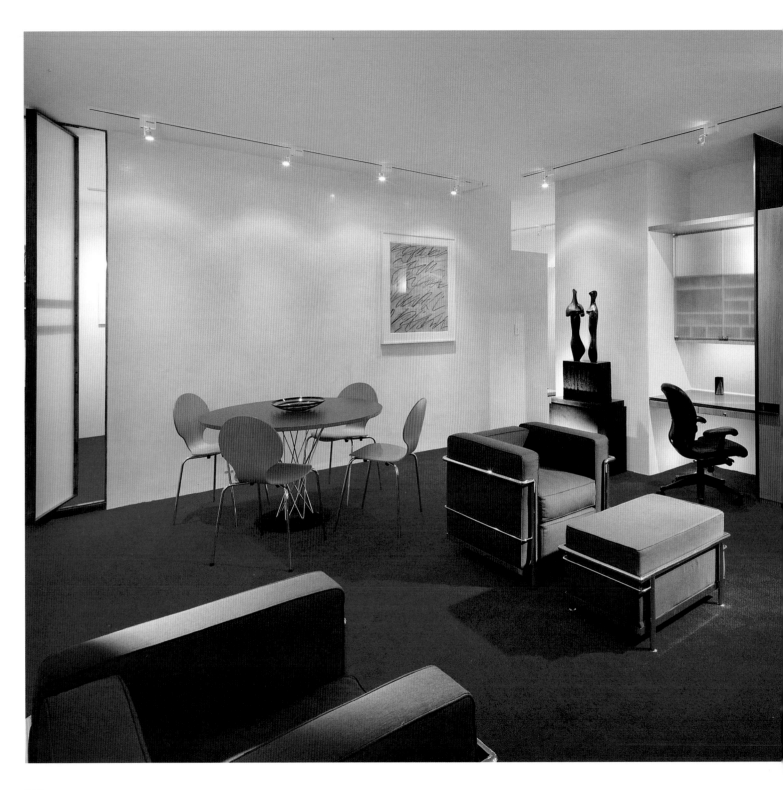

Left: Built-in cherry cabinets and desk adorn the west wall of the living room. The polished plaster wall separates the living room from the bedroom, which is accessible through the pivoting translucent glass plane.

Right (Top): A mirror adjacent to the entry door. The umbrella stand was designed by the architects and is available commercially. **(Bottom):** A detail of the cherry and steel side table designed by the architects for the living room.

FLOOR PLAN

Right: Computer-generated models were integral to the design of the apartment.

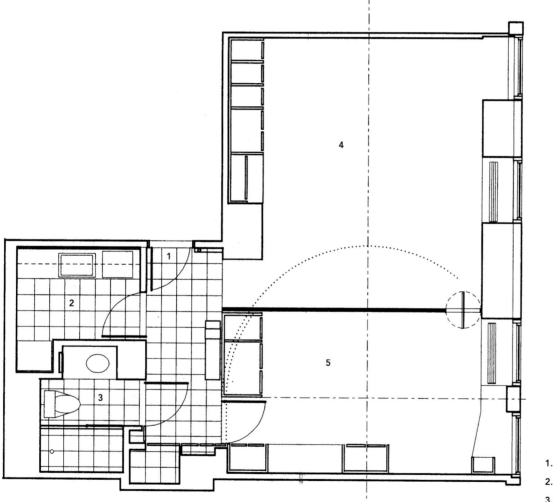

1. Entry
2. Kitchen
3. Bath
4. Living Room
5. Bedroom

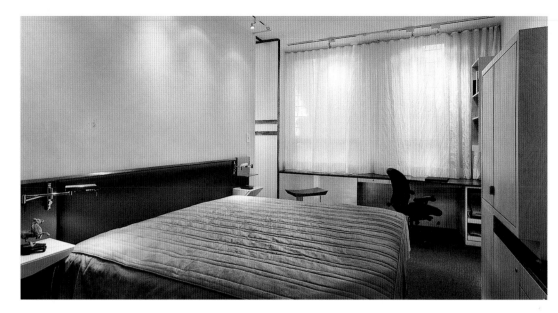

Left (Top): The bedroom has a built-in desk and media center. **(Bottom):** The cherry cabinet with the curved glass partition above it separates the bedroom from the foyer.

Right: There is direct access to the bathroom from the bedroom. Reflective surfaces in the bathroom visually connect it with the foyer.

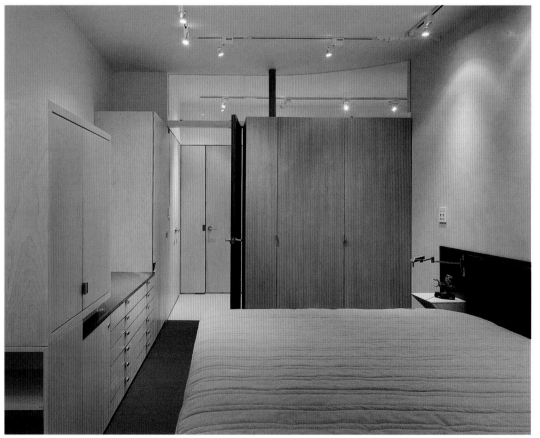

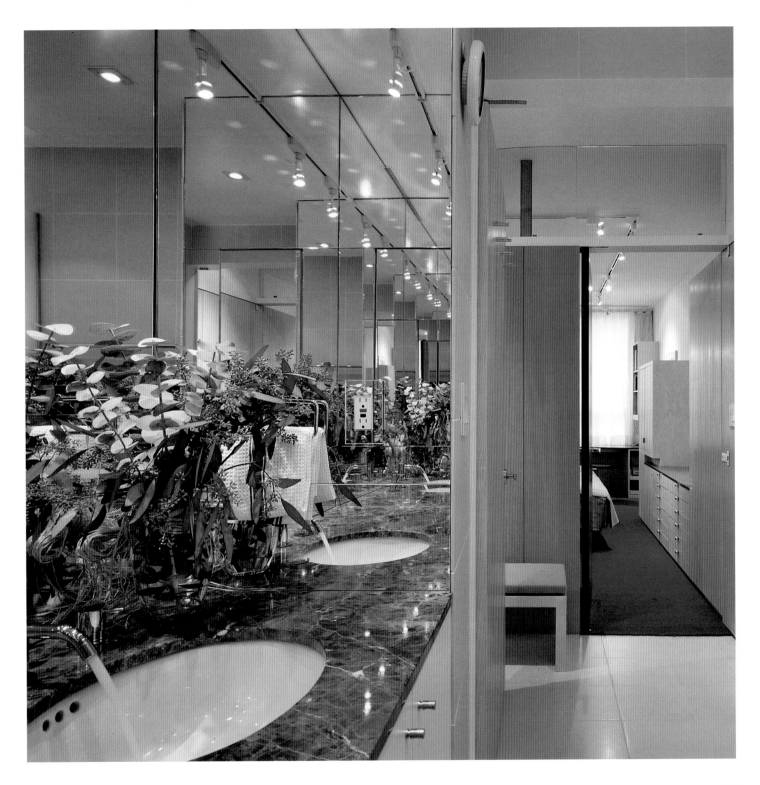

LUMINOUS WALLS

Anita Cooney & Anthony Caradonna
AC2

The architects were asked to expand the existing living area by connecting two small apartments. The owners were attracted to the character of the apartments, which are located in an older building. They feature curved archways and stepped levels that differentiated passage from the kitchen and dining areas to the living areas. The goal was to maintain this character and yet to energize it and create a new larger kitchen and a guest bedroom.

The entrance to the apartment is on axis with the kitchen. The facing wall/storage unit glows with the changing light of the day. The convex curve leads right to the living room, two steps below. Following the curve to the left is the dining area and the wall/storage unit that contains the new bedroom, which was the kitchen and dining area of the original apartment. The sleeping area is two steps above the dining area allowing the wall/storage unit to hover above the floor as if resting on a plinth.

Right: The dining area can be seen from the writing/library area. The translucent curved wall encloses the kitchen.

Photography: Alex McLean

BIG IDEA: The key architectural intervention is the two curved walls that are assigned multiple tasks of storage, division, and light diffusion. One of the walls separates the guest bedroom from the dining room and is the focal point of the view looking from the living room through the entrance toward the dining room. It is a "glow box" of subtle shifts in light, registering the change of light from day to night. The other translucent wall separates the kitchen from the entrance.

The walls are constructed of Lumasite, a flexible translucent acrylic panel material. Lights are hidden behind the top band of the Lumasite curve in both the entrance and dining areas, reflecting light upward, off the ceiling.

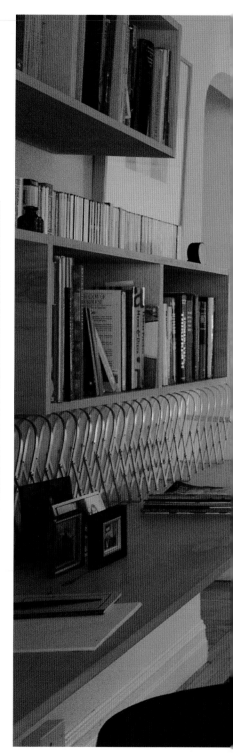

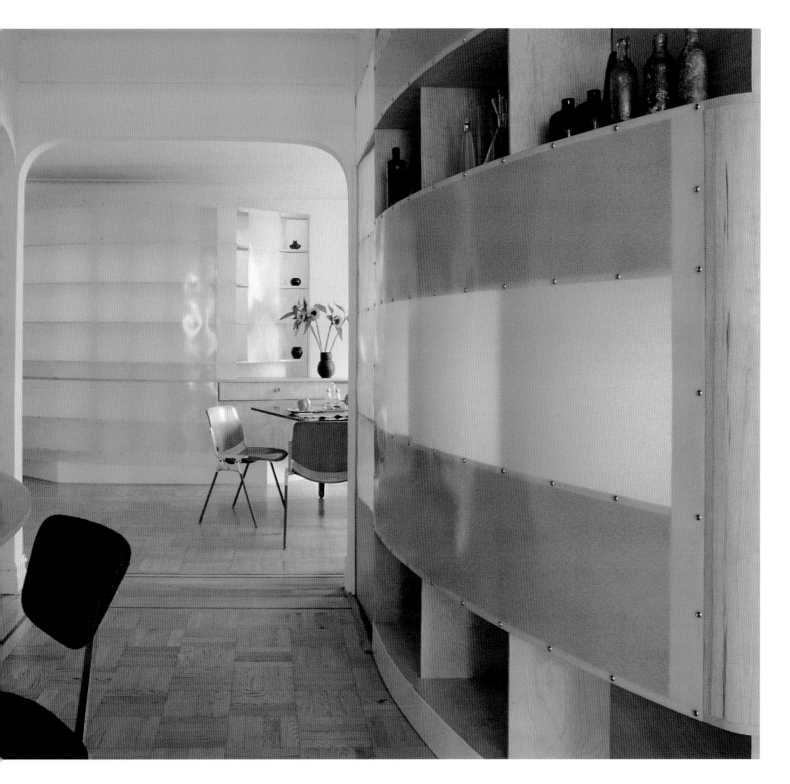

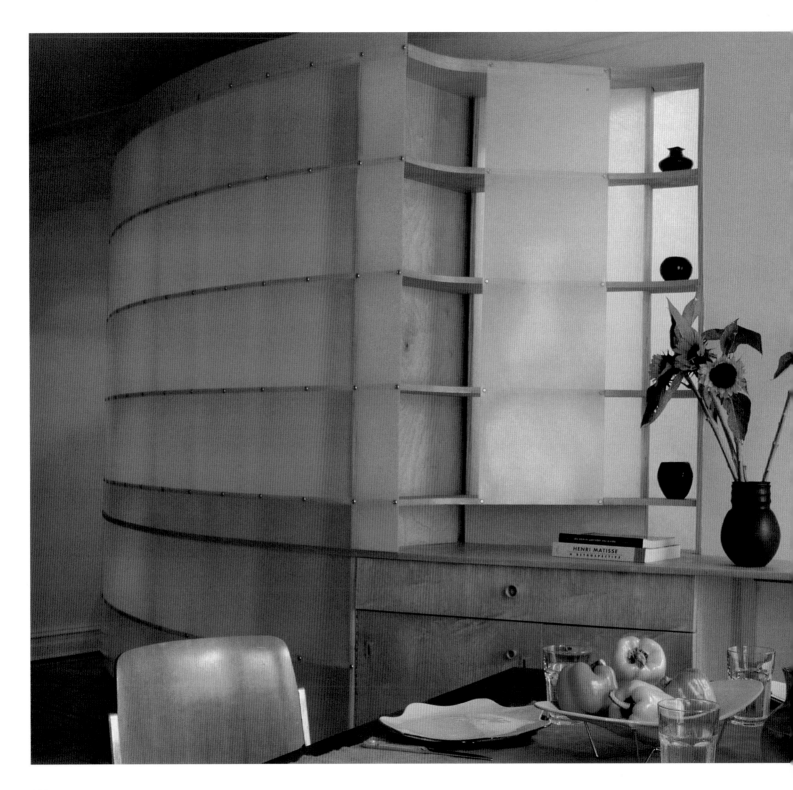

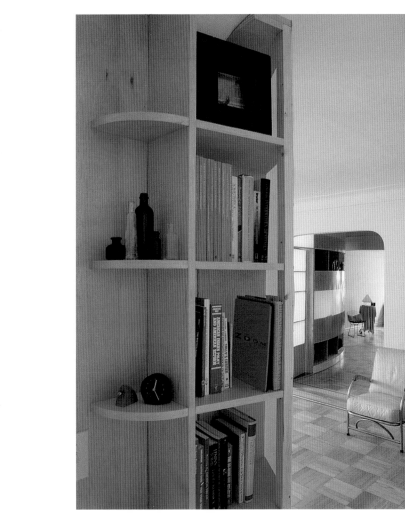

Left: View from the dining area. The translucent wall encloses the sleeping area.

Above: The edge of the curved wall near the entrance to the sleeping area. The waffle construction gives structural integrity to the wall and provides storage on both sides.

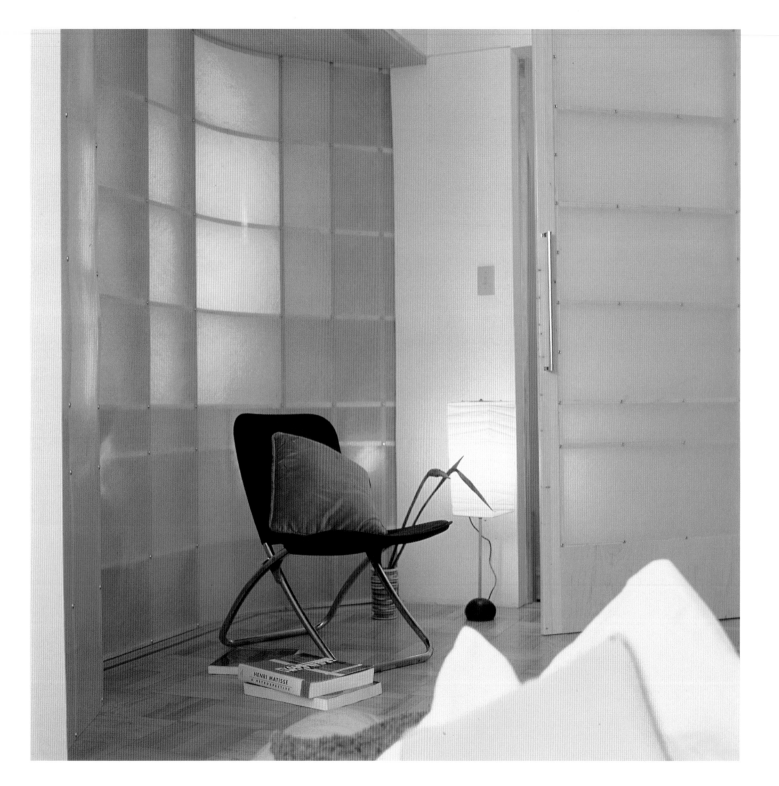

FLOOR PLAN

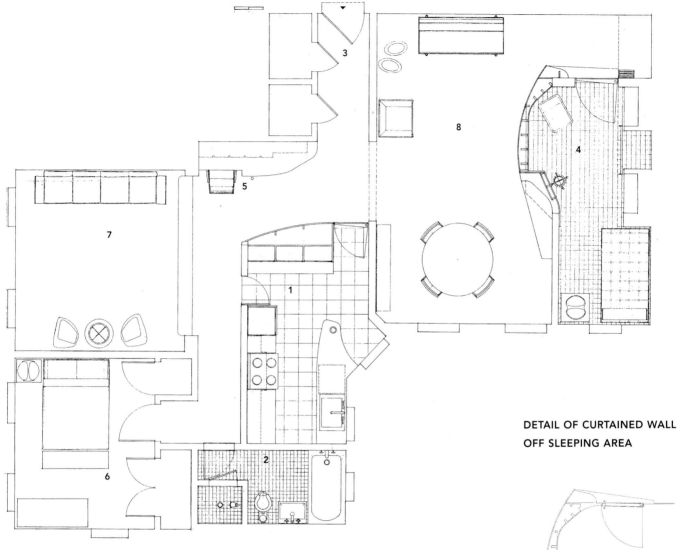

DETAIL OF CURTAINED WALL OFF SLEEPING AREA

Right: Inside the new, compact bedroom are two distinct areas: the concave curve of the translucent wall is a nest for sitting; closer to the window is another nest designed for sleeping.

Photograph: Scott Darling

1. Kitchen
2. Bath
3. Entry
4. Sleeping Area
5. Writing Area
6. Bedroom
7. Living Area
8. Dining Area

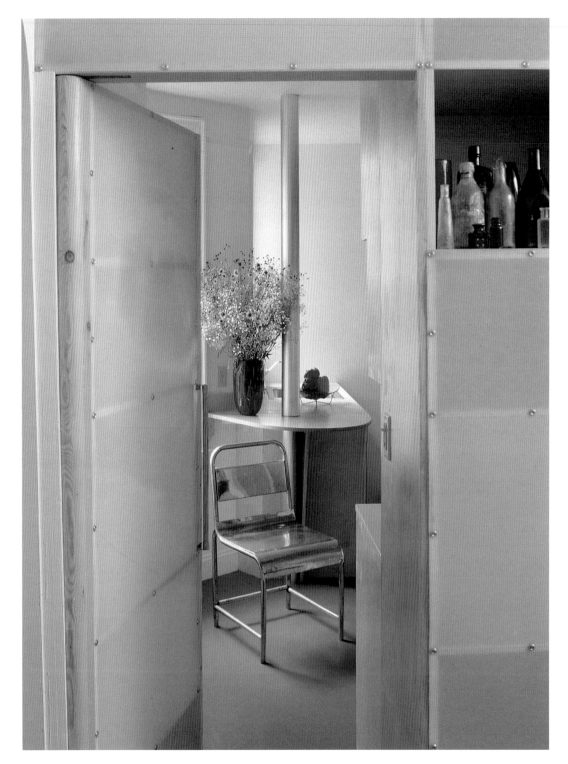

Left: Entrance to the kitchen, which is the geometric and social heart of the apartment. Unlike the rest of the apartment, it is finished in bold colors.

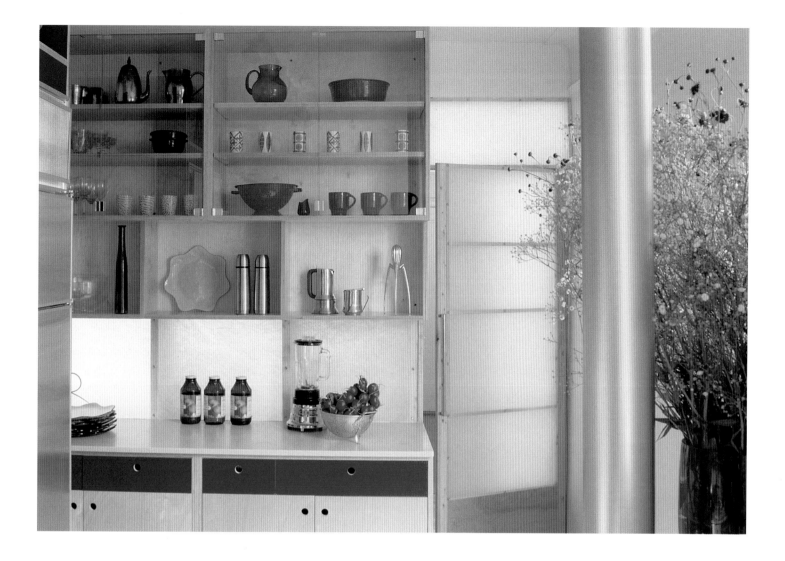

Above: In the kitchen, the cabinets are made of red and clear finply. Door and drawer pulls are eliminated. Instead, simple circular holes were cut, exposing the 12 layers of the plywood and creating a game of peek-a-boo with the supplies and dishes stored behind them. Other cabinets are left open, their contents and the construction revealed, in keeping with the character of the translucent wall/storage elements.

STRAIGHT PERSPECTIVE

Diana Viñoly

The owner is an independent studio photographer who wanted an apartment that serves as his home as well as a showplace for his work when meeting with clients and gallery owners. The apartment is in a modest building constructed in the 1920s for middle-income working families. To make the living/working space more suitable for her young avant-garde client, the designer broke up the conventional space using industrial shelving with stamped steel doors, lit by portable construction lights.

BIG IDEA:

While leaving the basic structure of the apartment intact, the designer was able to give it an "edge" by installing inexpensive industrial shelving across an entire wall of the apartment, including over a doorway. This wall of shelving also unifies the living and dining areas. To connect the kitchen to this space, a horizontal opening was cut between the kitchen and dining area. This opening allows the host to visit with guests while cooking and extends the view between the two rooms.

Right: The living area has industrial shelving continuing across the door to the dining area. Through the door is the bathroom on the right and the small bedroom beyond.

Photography: Michael Kleinberg

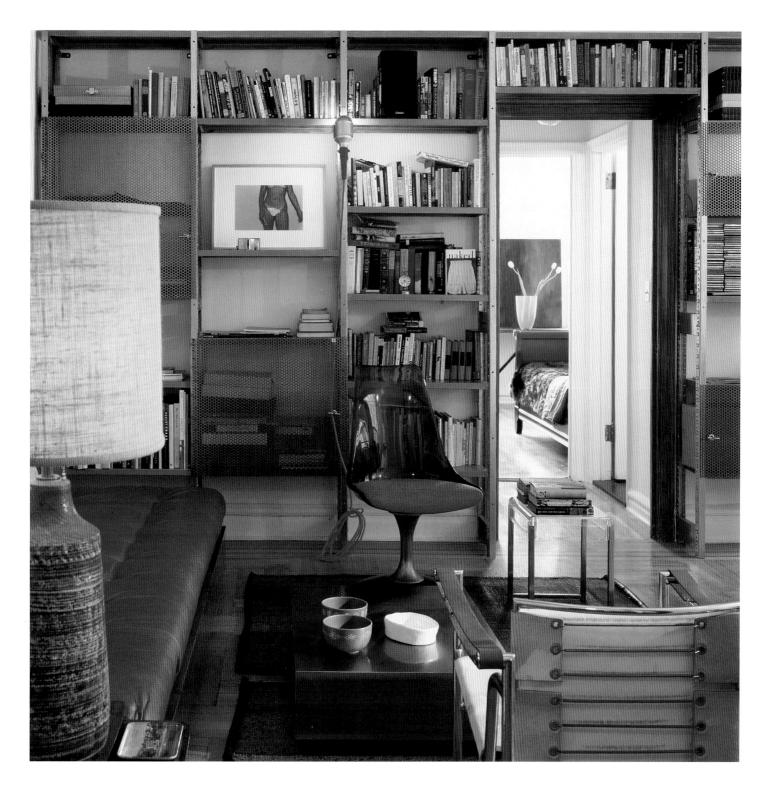

Left: The commercial/industrial theme is carried over into the bedroom, which also serves as an office.

Right: The industrial shelving with inexpensive construction lighting continues into the dining area.

FLOOR PLAN

1. Entry
2. Kitchen
3. Bath
4. Living Area
5. Dining Area
6. Bedroom

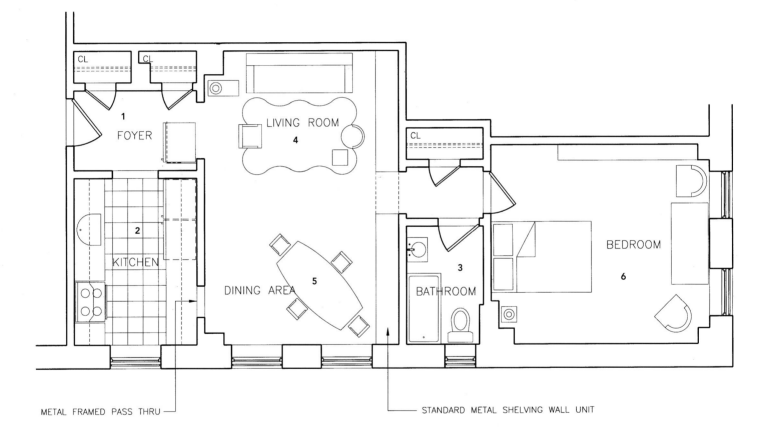

CL CL

1

FOYER

LIVING ROOM

4

CL

2

KITCHEN

DINING AREA

5

3

BATHROOM

BEDROOM

6

METAL FRAMED PASS THRU

STANDARD METAL SHELVING WALL UNIT

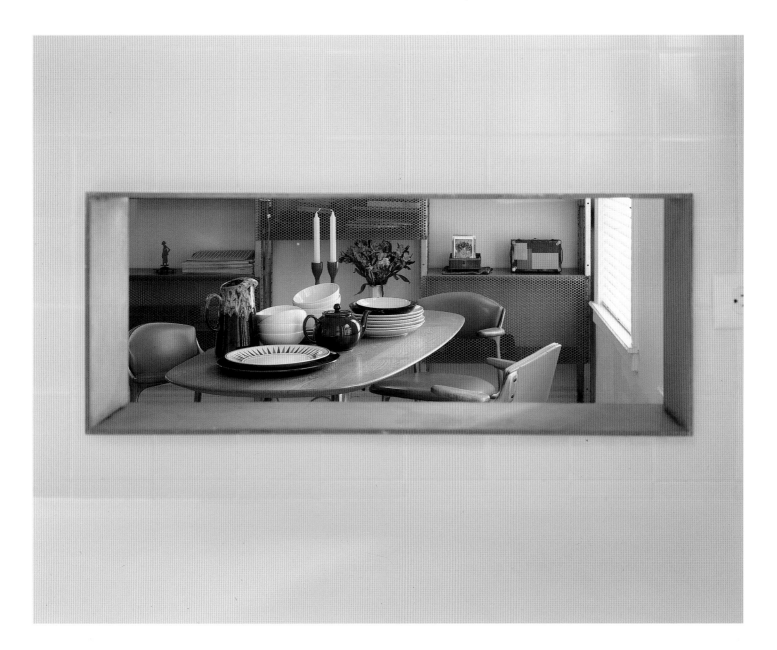

Above: This narrow horizontal opening visually connects the dining area with the kitchen.

OVERSTUFFED AND COZY

William Green

In this apartment, the architect approaches the space as a single room that features each of the requirements expected of a full-size home. There are several distinct areas within the main space of the studio, including the bedroom, office, living room, dining room, and library. Each of these areas can be enjoyed independently of the others, while the interweaving of the furniture, textures, and finishes achieves a cohesive unity when viewed as a single space. The walls are covered with paintings, mirrors, and various decorative objects in an eighteenth century "gallery style."

Above: The nineteenth century carved French sideboard houses the television and sundry decorative objects that trade routinely among the collection.

Right: The foundation of the apartment is an early twentieth century antique Chinese Art Deco carpet and an eighteenth century Hudson River bed.

Photography: John Nasta

BIG IDEA: The bounty of visual distractions, when applied ubiquitously yet harmoniously, become extremely comfortable and surprisingly subdued. At the same time, they can act as visual markers within the room to establish unique spaces for distinct activities.

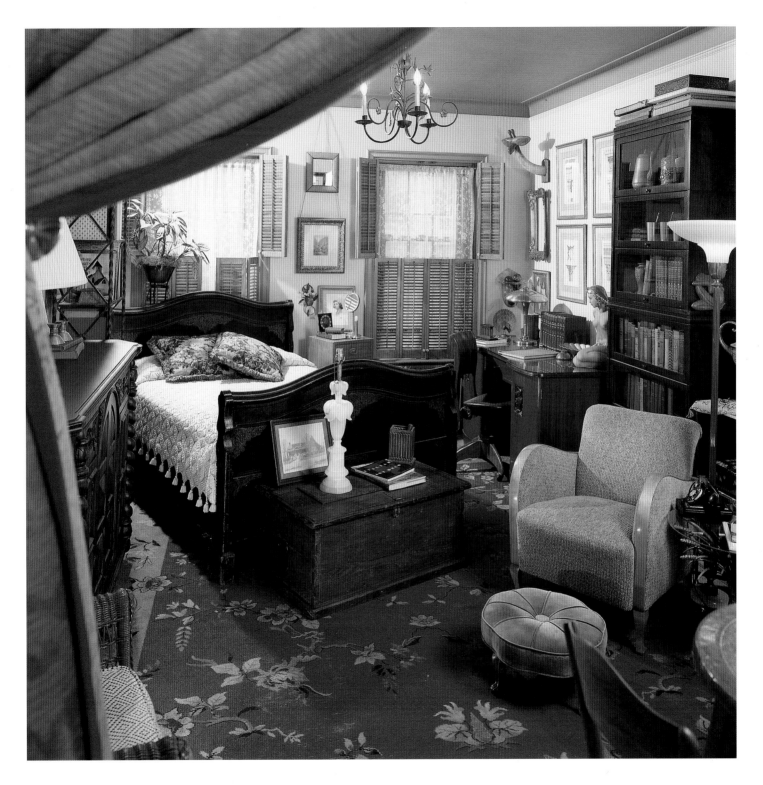

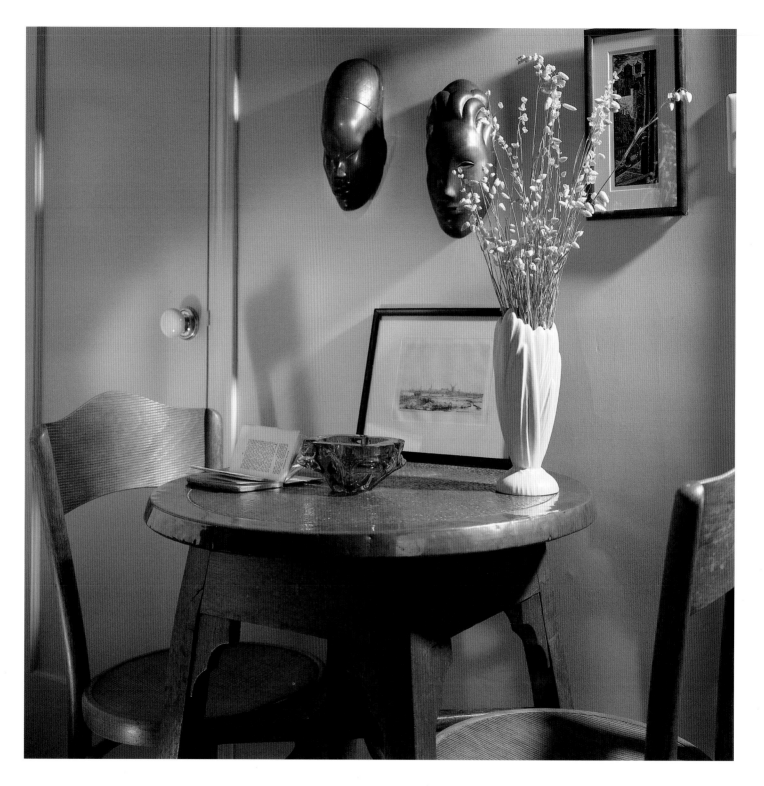

Left: Art, sculpture, accessories, and potpourri create an assemblage of vignettes.

Right: The walls are covered with paintings, mirrors, and various decorative objects hung in an eighteenth century "gallery style," providing a seamless display of visual and textural activity from the furniture to the crown molding of the ceiling.

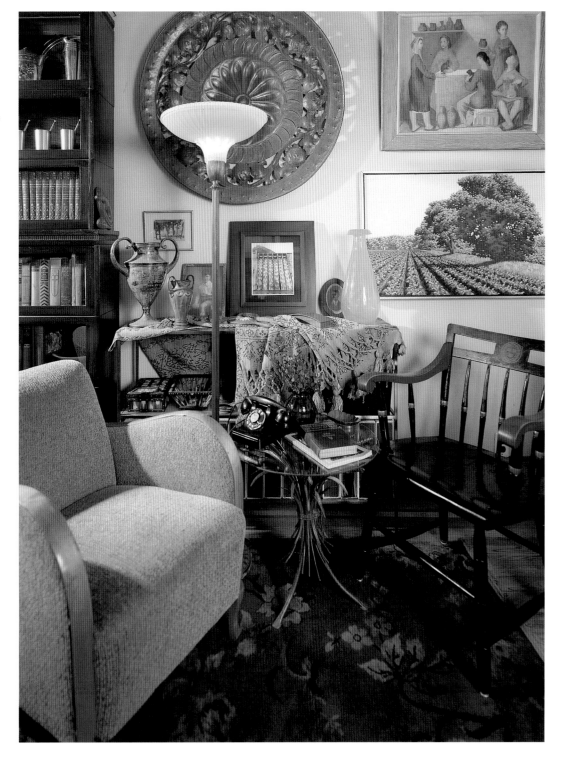

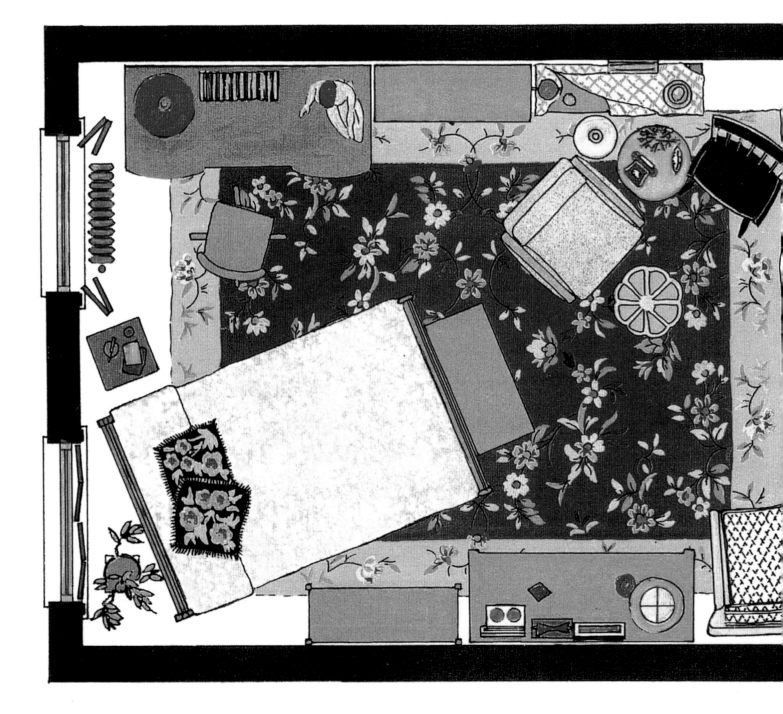

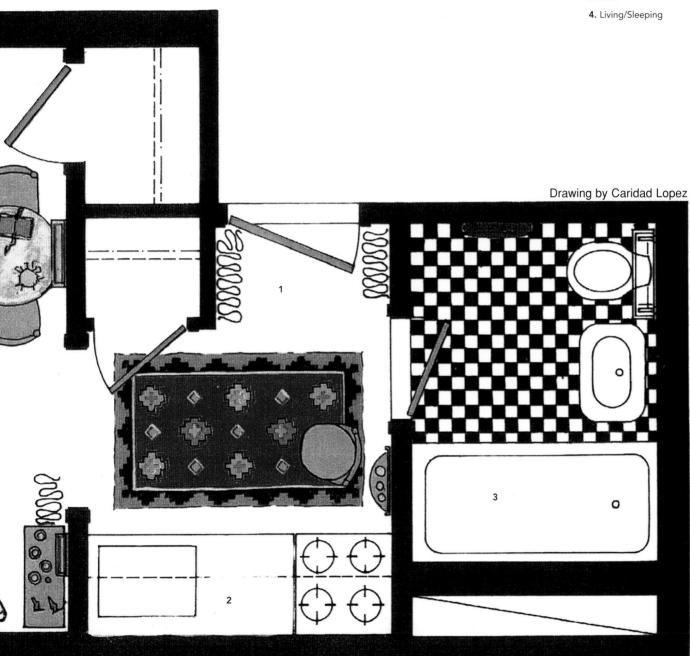

1. Entry
2. Kitchen
3. Bath
4. Living/Sleeping

Drawing by Caridad Lopez

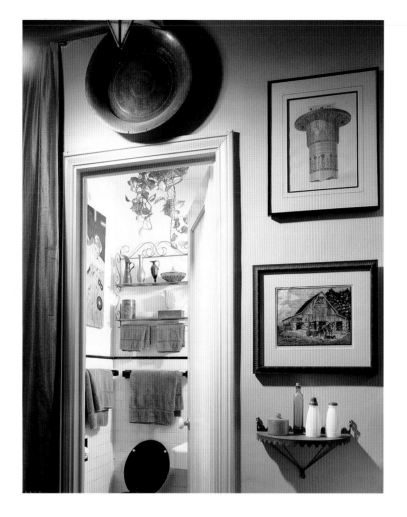

Above: A view to the bathroom from the kitchen/entrance foyer.

Right: The drapery on the left, when closed, separates the living/sleeping area from the kitchen and foyer.

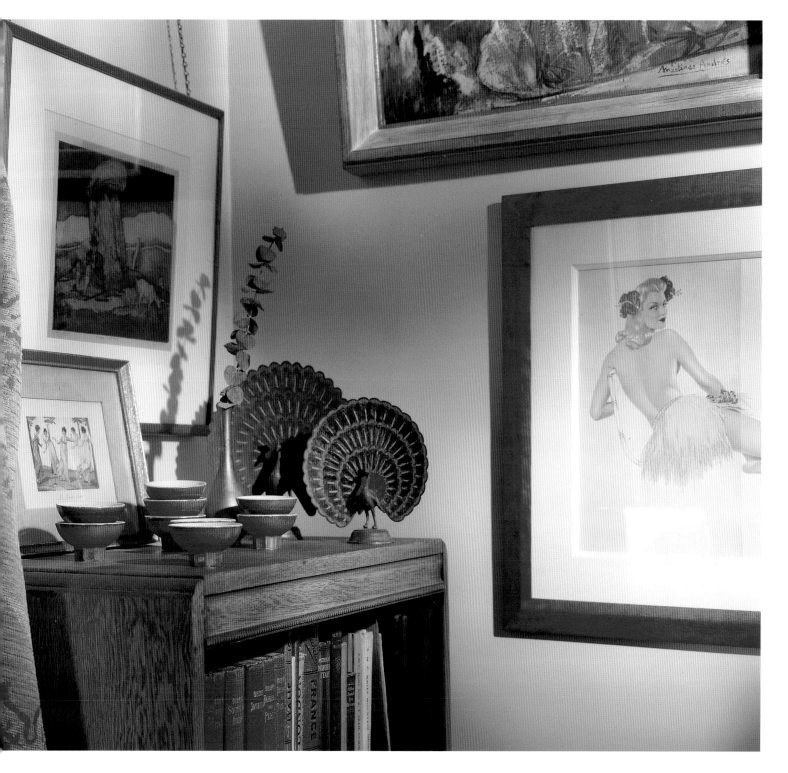

USING THE OLD BEAM

Ken Kennedy

Apartments in older buildings are often chopped into several small rooms, resulting in cramped, dark spaces that have limited use and often disguise what may turn out to be a bright, open space with high ceilings. Such was the case with this apartment owned by a book publisher. The architect divided the space into two main areas, living/entertaining and quiet/sleeping. A walk-in dressing room which is clad in maple panels becomes the spatial division between these two areas. The demolition of the existing bedroom wall and the installation in its place of full-height sliding walnut doors allowed for a range of open/closed spatial possibilities.

Right: A view from the living area to the dining area reveals the strong beam structure throughout the apartment. The architect's use of bold color and uplighting accentuates this structure. The dining table and chairs are by Le Corbusier.

Photography: Paul Warchol

BIG IDEA: The architect used the existing strong ceiling beam pattern to accentuate the different functions of sitting and dining within the overall living space. To further emphasize the beams, bold blocks of color painted between them were integrated with the furniture and paintings. Lighting was developed in association with these spatial and visual treatments. The concealed lighting strips behind wall panels provide an ambient uplight, visually extending the ceiling height.

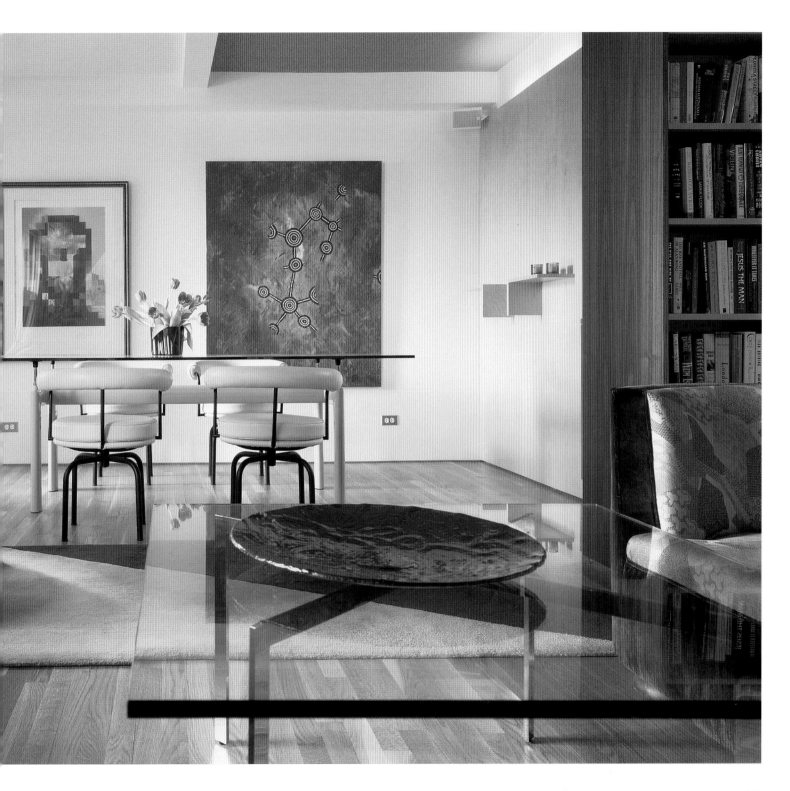

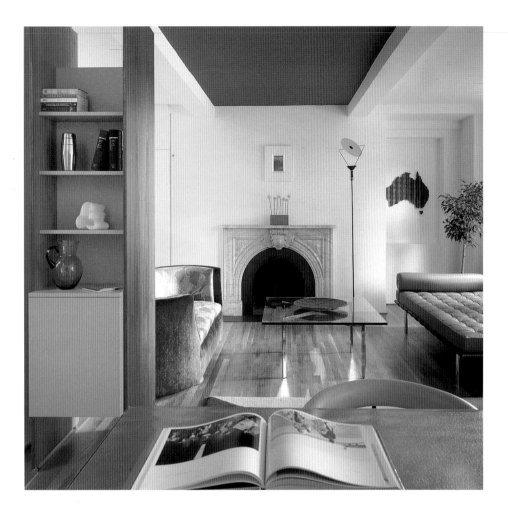

Above: The fireplace mantel, the only original feature of the apartment, functions as a counterpoint to the modern furniture.

Right: In this sweeping view of the dining area, corridor to the sleeping area, kitchen, and living area, the spatial flexibility achieved by the sliding walnut doors and the ceiling beams is apparent. Although the kitchen extends into the living area, the cabinetry conceals any overt kitchen references.

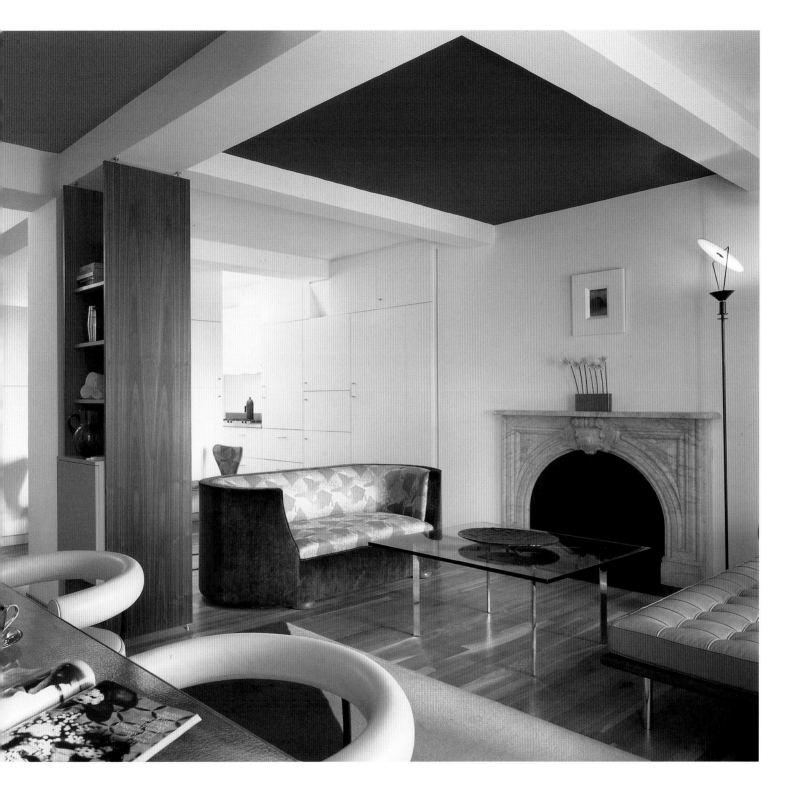

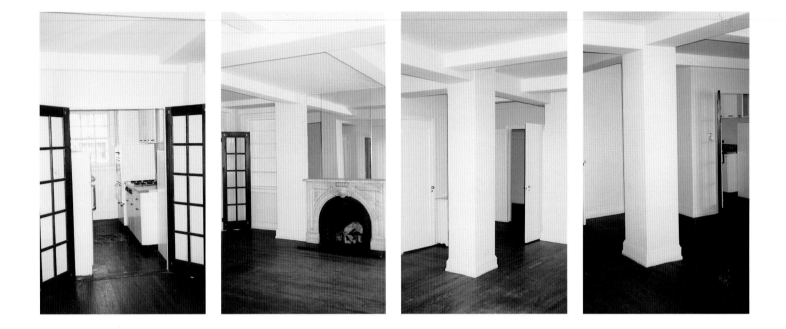

ORIGINAL FLOOR PLAN
(DOTTED LINES INDICATE BEAMS)

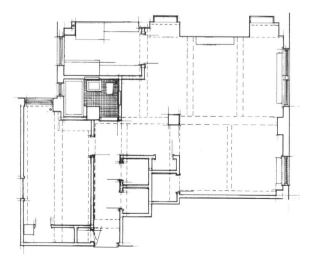

Above: Various views of the apartment before the renovation.

RENOVATION FLOOR PLAN

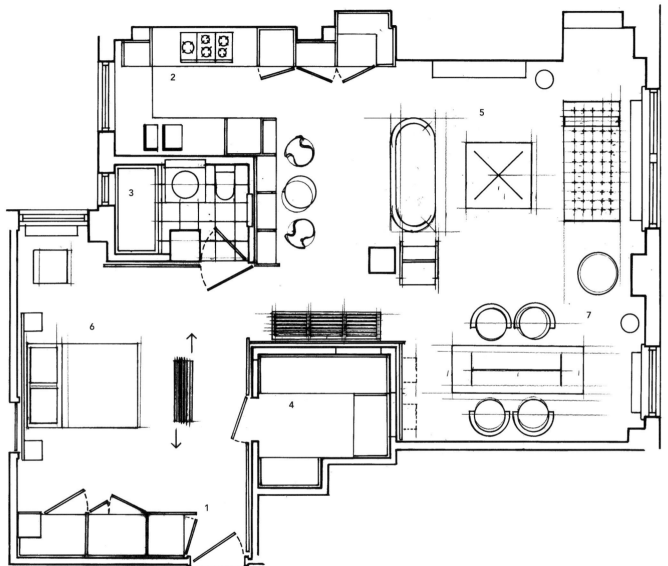

1. Entry
2. Kitchen
3. Bath
4. Walk-in Closet
5. Living Area
6. Sleeping Area
7. Dining Area

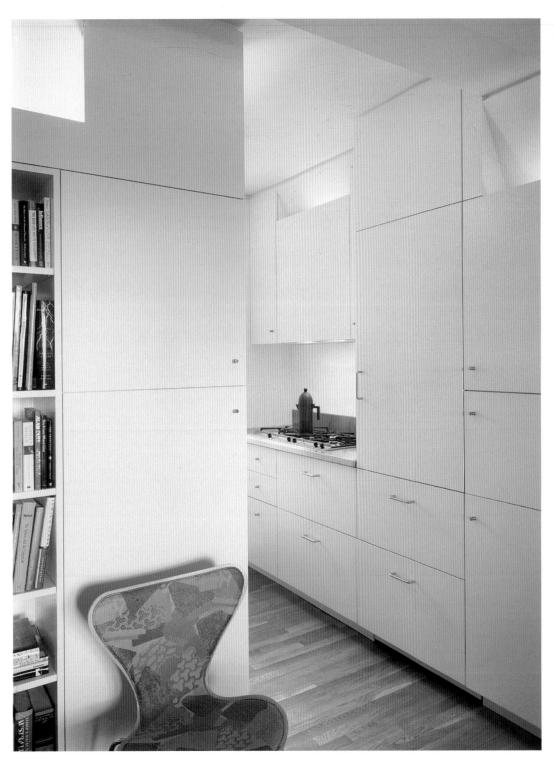

Left: Although the kitchen extends into the living area, the cabinetry conceals any overt kitchen references such as the refrigerator (right of the cooking surface) and pantry (right). The beam and uplighting serve to visually separate the kitchen from the living area.

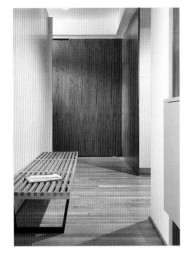

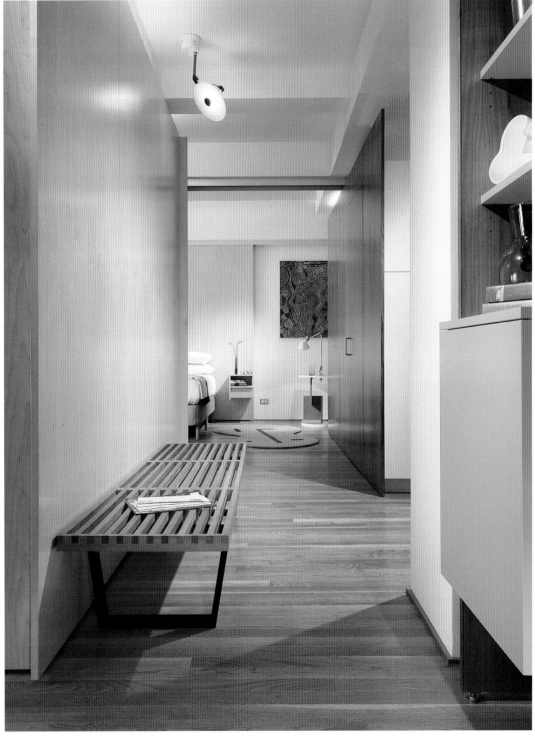

Above and Right: The sliding walnut doors closed and open, revealing the sleeping area beyond. A George Nelson bench is placed in front of the walk-in closet accessible from the sleeping area.

LIGHT AND REFLECTION

Frederick Biehle & Erika Hinrichs
Via Architecture Studio

BIG IDEA:

The central feature of the apartment is the voluminous bathroom that pushes against the rectangular frame of the open space. At the entrance, the swollen, oval-shaped wall of the bath blocks the view of the living space, creating a contrast between the tight, narrow entrance and the open space beyond.

The owner of this apartment is works for a law firm specializing in entertainment law. VIA Architecture designed this 600-square-foot apartment to be a simple but subtle, opalescent space where the owner could spend tranquil, meditative nights–the antithesis to her hectic activities during the day. They achieved this through the restrained use of materials, monochromatic colors, and modest but whimsical lighting effects.

The sleeping area and the bathroom are defined by opaque, translucent glass walls that reveal the moving figure within the spaces. The translucent walls also provide intriguing lighting effects throughout the day and evening. The floating, rotating mirror attached to the edge of the sleeping area catches the oblique view of the southern skyline visible from the main window and projects it into the interior of the apartment.

Right: The translucent volume of the bedroom and bath define the open space of the living room.

Photography: Lynn Massimo

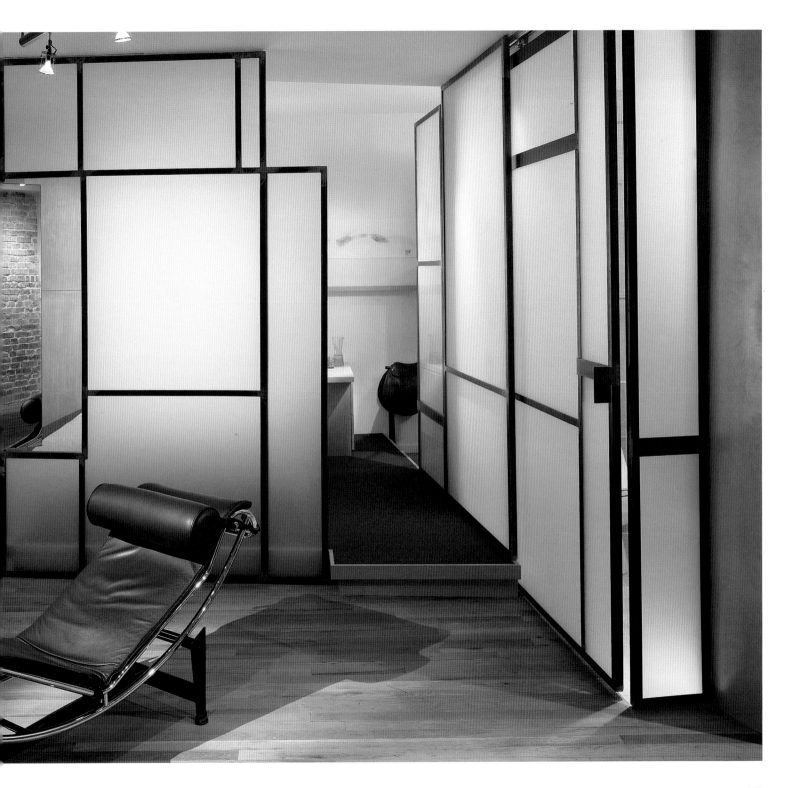

FLOOR PLAN

1. Entry
2. Kitchen
3. Living/Dining
4. Bedroom
5. Bathroom
6. Dressing

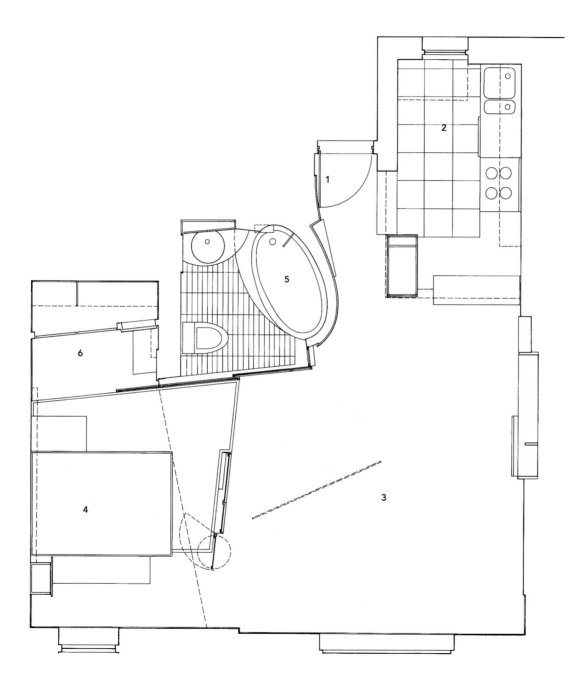

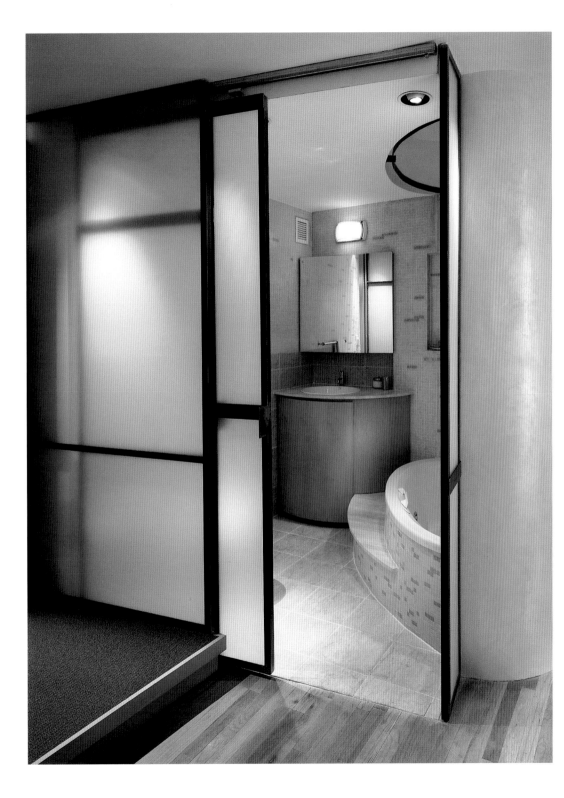

Left: Glass and limestone tiles are used in the bathroom. The walls are sand-blasted glass set in a hot-rolled metal frame.

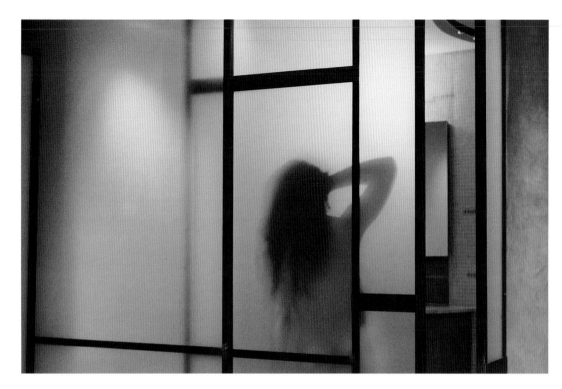

Left: A moving figure can be seen from within the translucent shell of the bathroom.

Bottom: Depending on the angle, the perpendicular mirror reflects the southern skyline or interior views of the apartment.

Photographs: Frederick Biehle

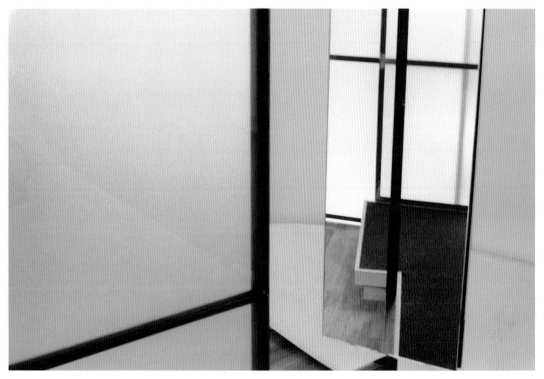

Right: The kitchen counters are limestone tile with hot-rolled metal edges. The custom cabinets are maple with a gray stain.

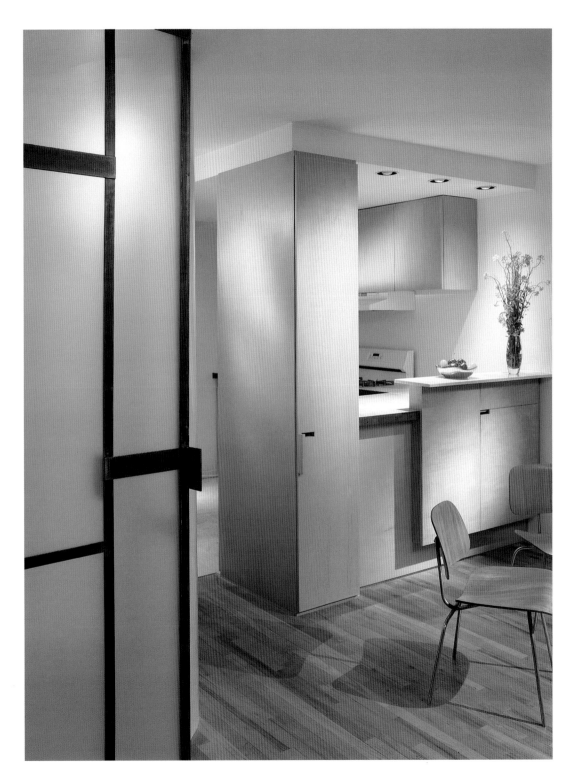

URBAN RETREAT

Parsons + Fernandez-Casteleiro, Architects

BIG IDEA:

The salient design feature is the creation of separate zones for living or entertainment within one space. This is achieved through the use of permanent and movable screens to create maximum flexibility and diversity within the space. For example, to separate the dining area and kitchen from the living area, there is a rolling space divider made of panels of sanded polycarbonate suspended on an exposed ceiling track. Within the custom-designed wall unit in the living room is a fold-out bed for use by overnight guests. With the bed open and the dining room closed off by the divider, the guest has in essence a private bedroom.

Right: The living area is defined by two main walls. On the right is a rolling partition made of sanded polycarbonate panels which conceals the dining area and kitchen entrance. The wall at the end is made of linoleum sheets framed in aluminum strips that continue on to the floor.

Photography: George Higgins

Having a pied-à-terre in the city for weekends and late night theatre use is the dream of many. Creating such a stylish retreat that can also be used to host small dinners and pre-theatre cocktail parties can be a challenge. For this apartment, the architects employed a variety of design solutions to create a stunning, highly efficient urban retreat.

Key to the visual appeal of the apartment is the use of high-tech industrial materials set against rich lacquered wood furnishings, partitions, and bookcases. Linoleum sheet goods are used for the walls, sanded polycarbonate panels for rolling partitions, and aluminum and lacquered paints are applied on walls and ceilings.

Lighting also plays an important role. Fluorescent cove lights are used for general illumination, and recessed mini-cabinet lights are inserted into dropped ceiling areas. For the hall, custom floor lights are suspended from the ceiling, and in the bathroom there is a suspended polycarbonate light diffuser.

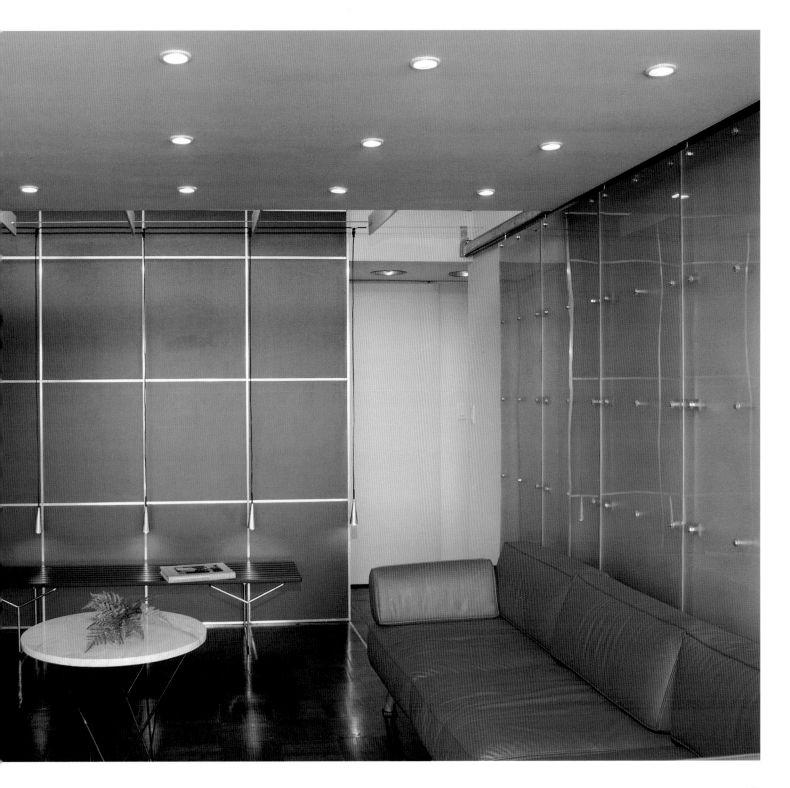

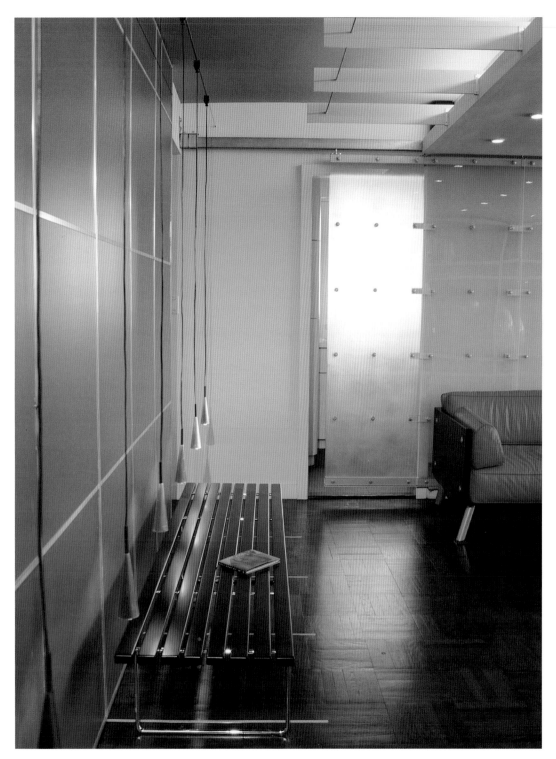

Left: The view from the entry foyer to the kitchen, which is intersected by the rolling partition. A continuous line of suspended ceiling lights to illuminate and accent the floor of the entry were fabricated using standard aluminum cones and miniature incandescent bulbs. The bench is by Harry Bertoia.

Right: In the living area, the modular bookcases were custom designed by the architects. A fold-out bed is concealed in the space behind the painting.

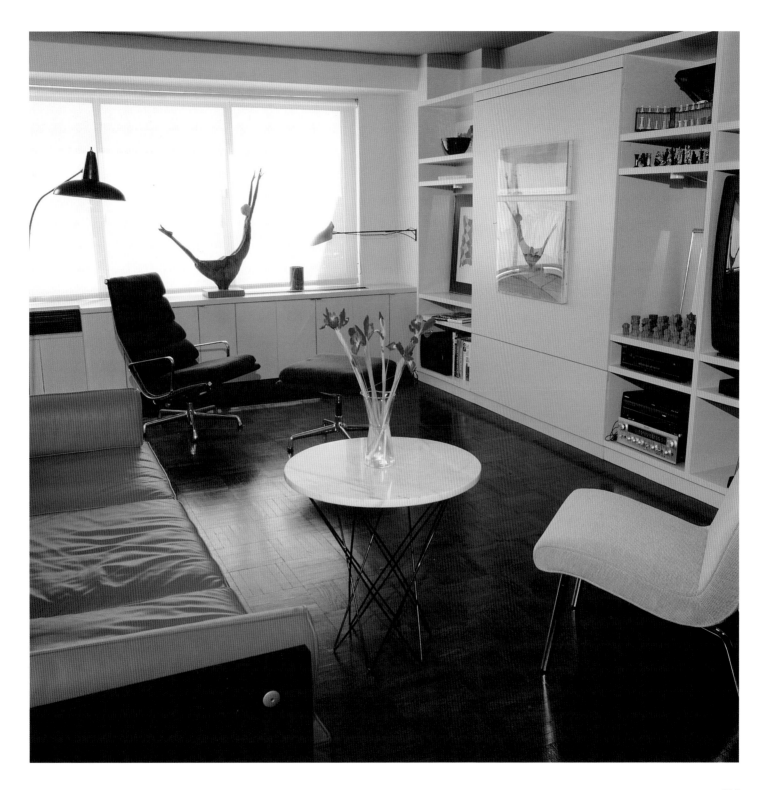

FLOOR PLAN

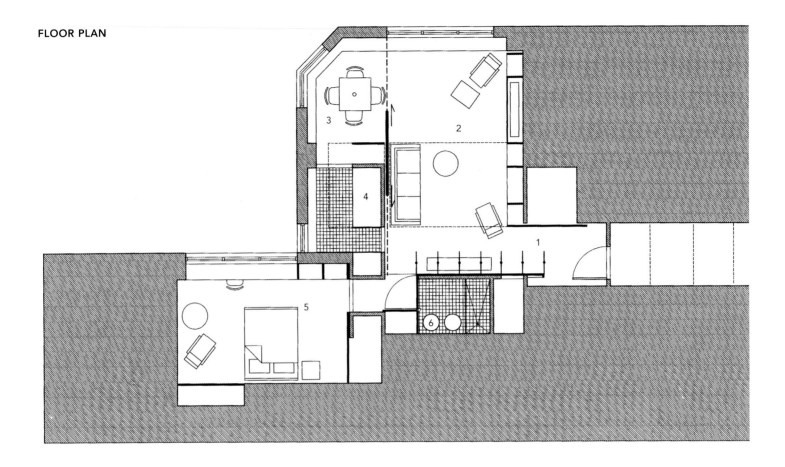

1. Entry Hall

2. Living Area

3. Dining Area

4. Kitchen

5. Sleeping Area

6. Bathroom

CEILING PLAN

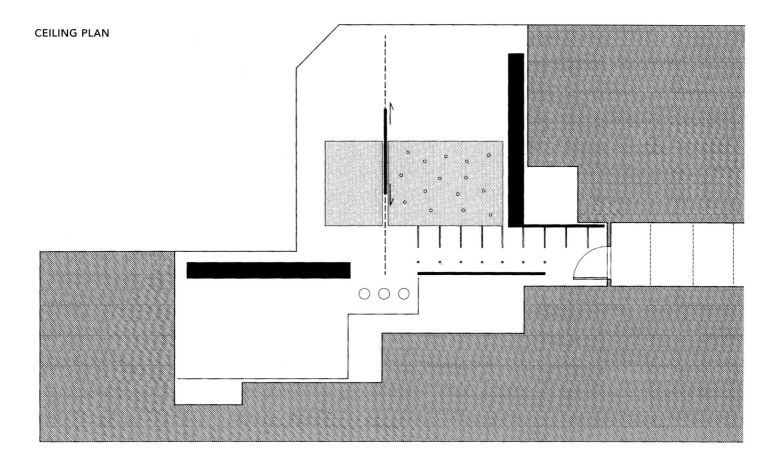

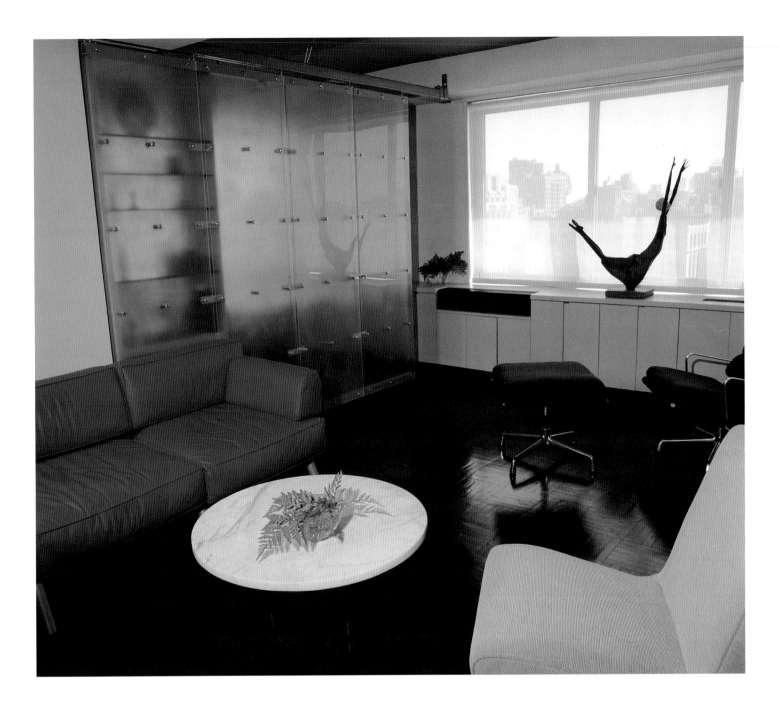

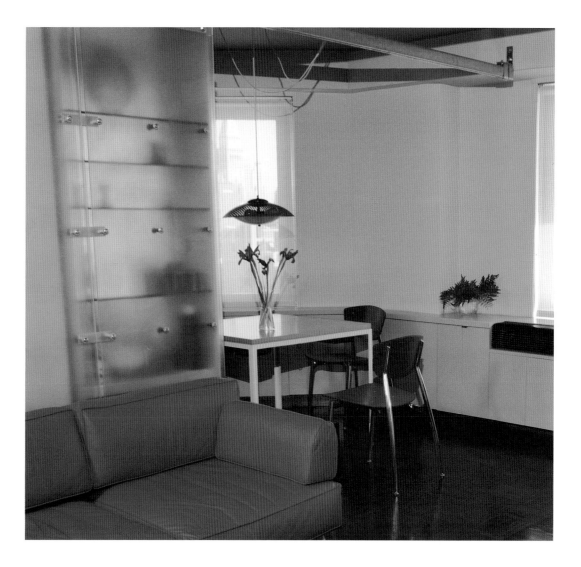

Left: The rolling partition in the closed position.

Right: The partition in the open position, revealing the dining area.

Following Pages (Left): The fold-out bed in the closed position. **(Right):** The bed in the open position.

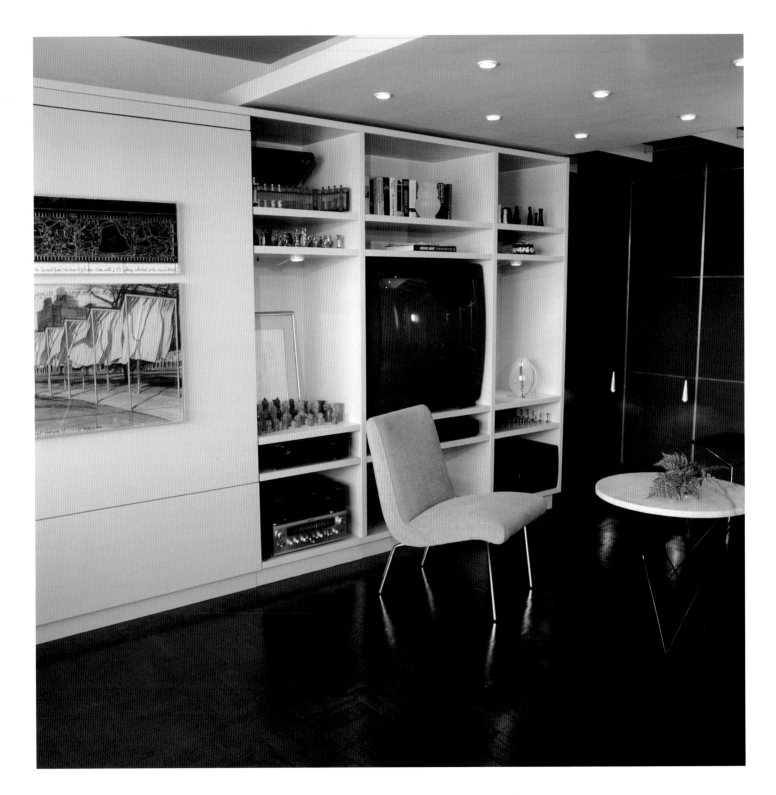

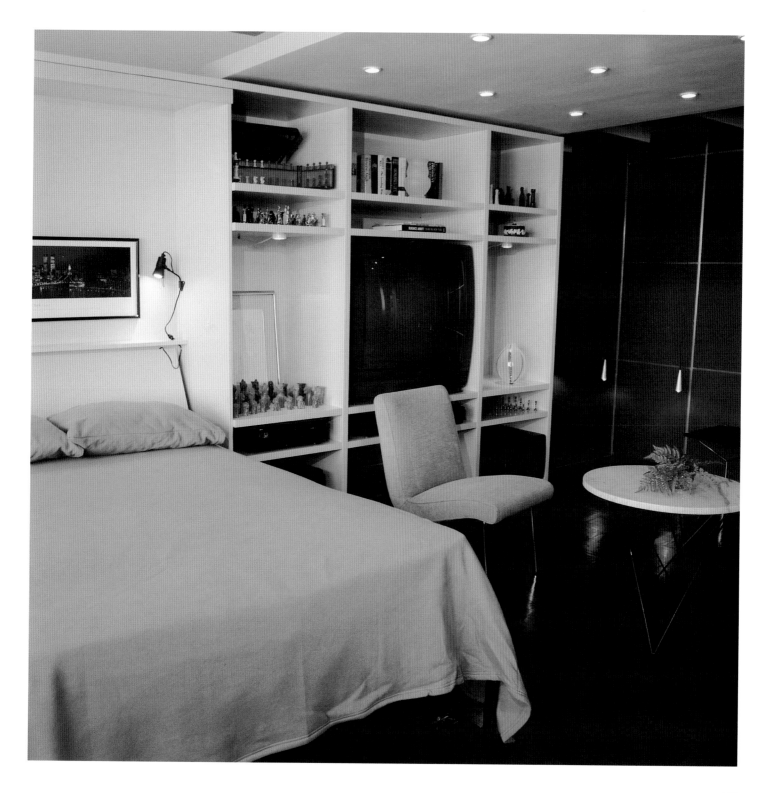

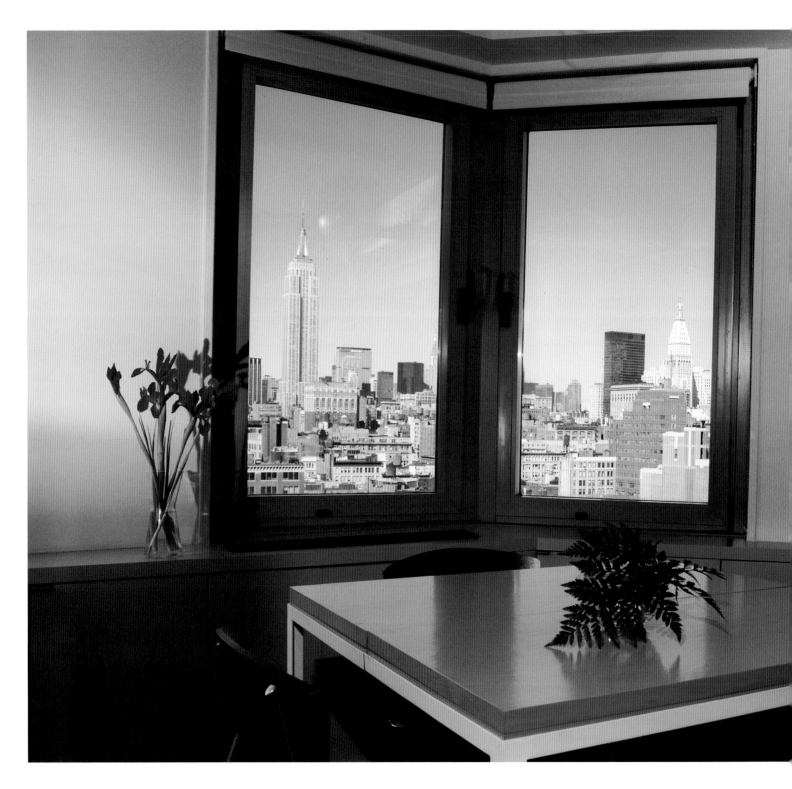

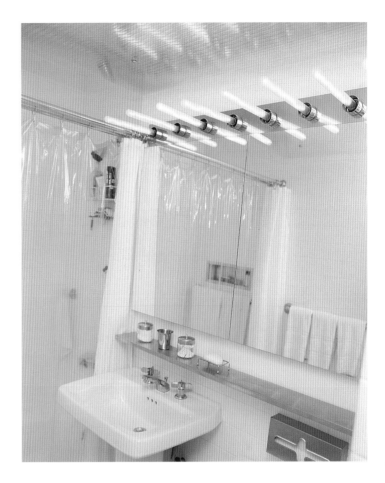

Left: The dining area overlooks midtown Manhattan.

Above: The bathroom features a suspended polycarbonate light diffuser.

TIME AND SPACE

Marco Pasanella

Above: A mirror covers the back of the cherry cube that houses the televisionn, which swivels from room to room on a lazy Susan.

Right: Two doors of translucent glass hide the unsightly burglar bars on the windows yet admit ample light into the living room. Between the windows is a custom-designed cherry bookcase with a pull-up desk.

Photography: Paul Warchol

This is a story about careful spatial planning and organization, about accommodating the client's disparate collections while creating a fully equipped home, all in 750 square feet. The solutions included having furniture serve multiple functions and designing storage and display spaces that were simple and highly functional. A hole was cut into the wall between the living room and bedroom to accommodate a television which swivels back and forth. The coffee table is a piece of glass on storage cubes that can be stacked to create a dining table. There are two fold-out tables: one in the living room which becomes a desk, the other in the small kitchen. Custom-designed shelves and display racks provide space for the many collectibles.

BIG IDEA: The view from the living room of the apartment was through unsightly burglar bars onto a noisy street. Rather than use draperies or other window coverings that would diminish the light, cabinetry was designed that covers the entire window wall of the living room. It conceals the heating system below the windows, and the windows themselves are covered by large doors of frosted glass which hide the bars, mask the noise, but allow ample light into the apartment. Made of cherry, the unit contains a pull up desk and storage space for books and CDs.

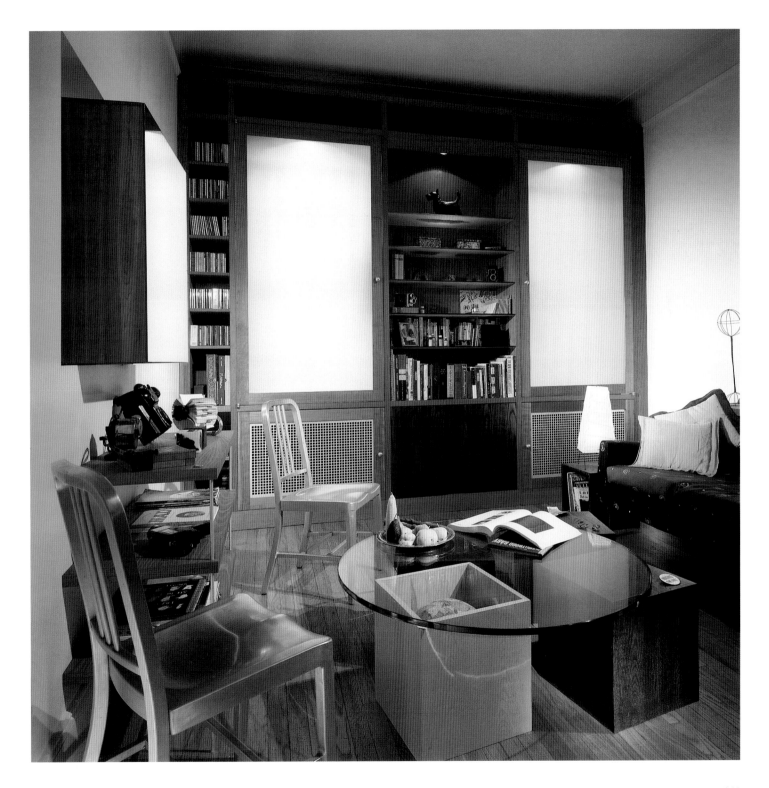

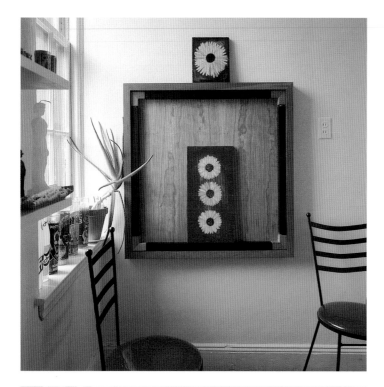

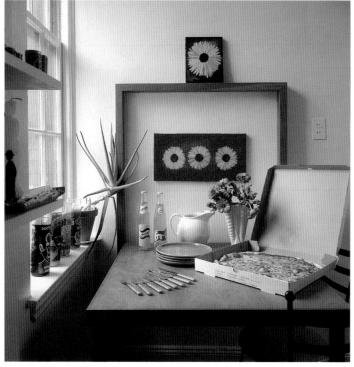

Left (Top): In the small kitchen, a dining table folds up like a Murphy bed.

Left (Bottom): The table in the opened position.

Right: A view into the kitchen from the apartment's entrance.

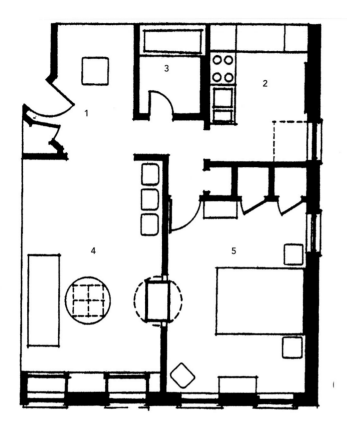

1. Entry

2. Kitchen

3. Bath

4. Living Room

5. Bedroom

Right: The bedside tables and bureaus
were designed by the architect.

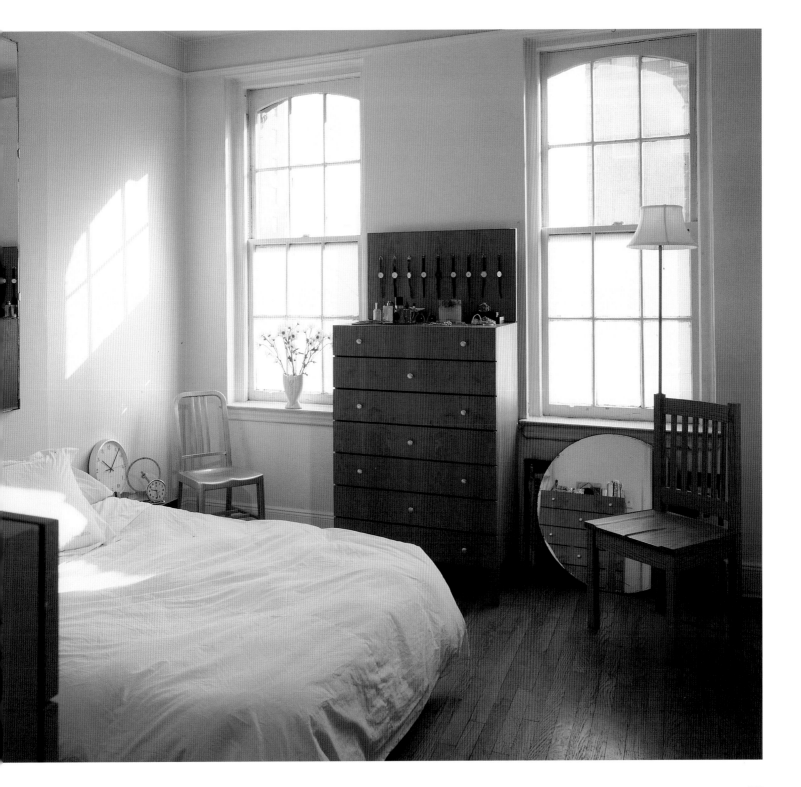

Left, Below, and Right: The client required clear, practical solutions for displaying her disparate collections, ranging from unusual international grocery items to an extensive watch and clock collection.

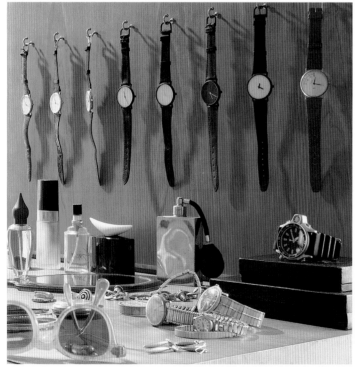

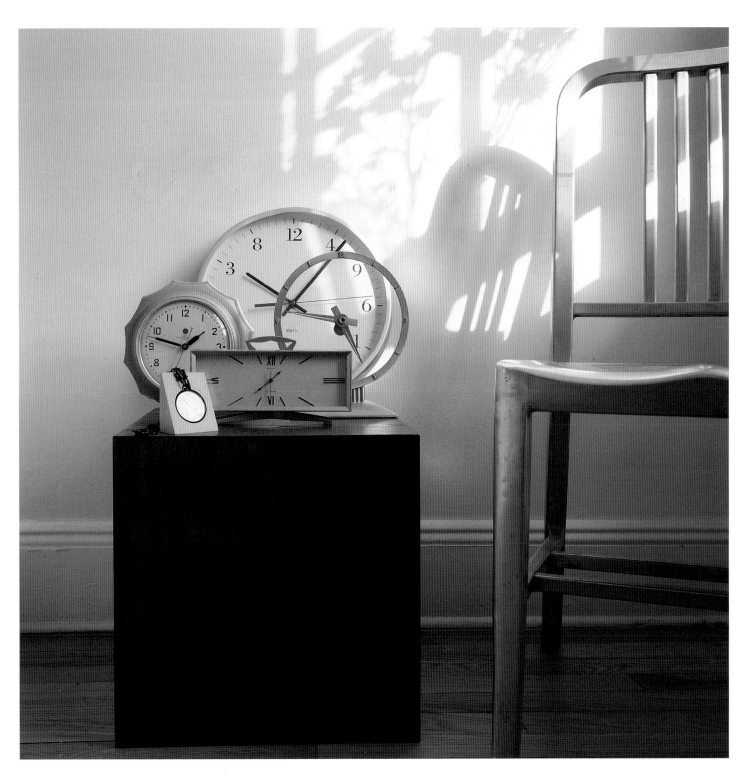

ATOP PARIS

Mark Guard

BIG IDEA:

The space is basically composed of three free-standing "boxes" containing the washing machine, refrigerator, wardrobes, and television. By using these 'boxes', a pivoting door, and a number of sliding doors, the interior of the apartment can be changed as needs require. The bedroom can be part of the open plan or separated. The bathroom can be en-suite or accessed separately from the living spaces. A storage wall surrounds the stainless steel kitchen. The countertop extends into the bathroom separated by Priva-lite glass: closing the bathroom door activates the glass changing it from clear to opaque.

This is an extraordinary 350-square-foot "building" that sits on top of a large expanse of flat roof of an eight story 1930s apartment building in Paris. The roofscape has to be crossed in order to reach it. The west wall of the "building" was removed and replaced with a folding glass wall and a glass canopy. The canopy allows the doors to remain open during a summer rain. A French limestone floor is laid throughout the apartment, extending onto the terrace which overlooks the historic core of Paris. Modern technology allows the owner, whose main residence is in London, to activate underfloor heating and water heaters by telephone prior to his arrival in Paris.

Right: Spectacular views of the historic core of Paris can be seen from the limestone terrace.

Following pages (Left): The west wall of the apartment was removed and replaced by a folding glass wall and glass canopy. **(Right):** A view of the living space, the floating kitchen counter, and the movable wall concealing the bedroom.

Photoraphy: Jacques Crenn

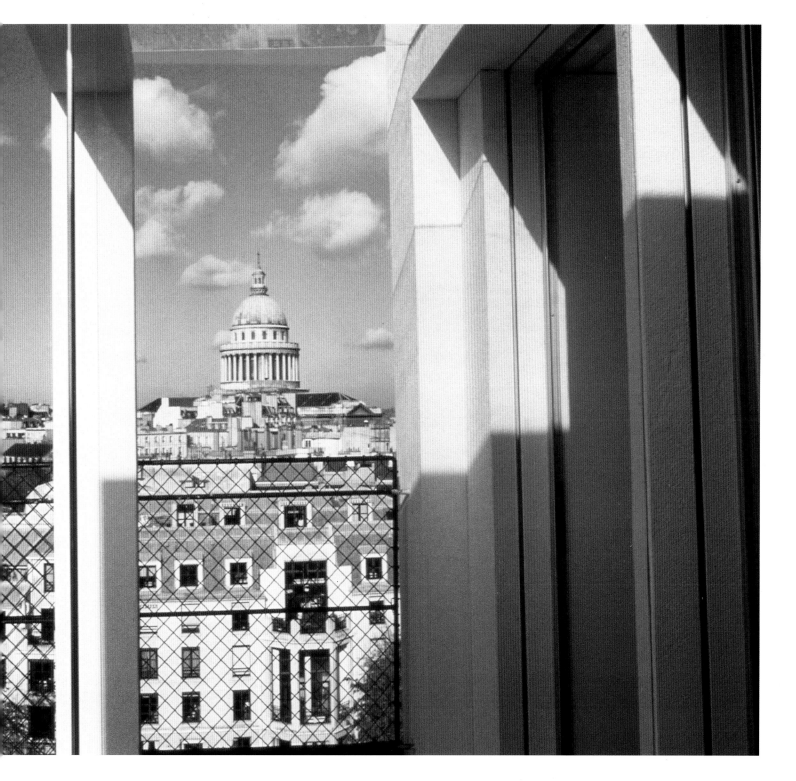

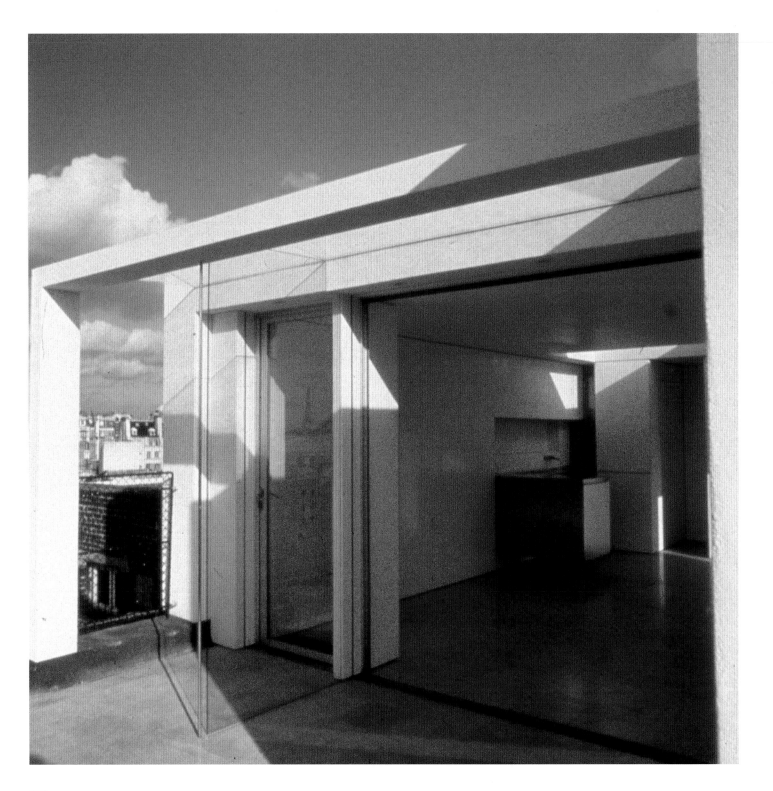

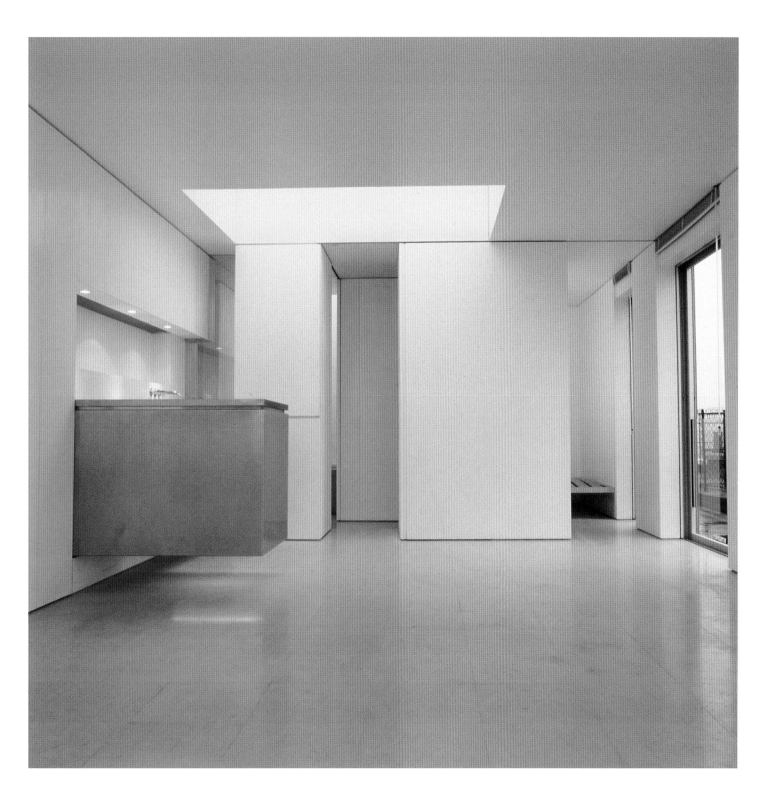

AXONOMETRIC PLAN

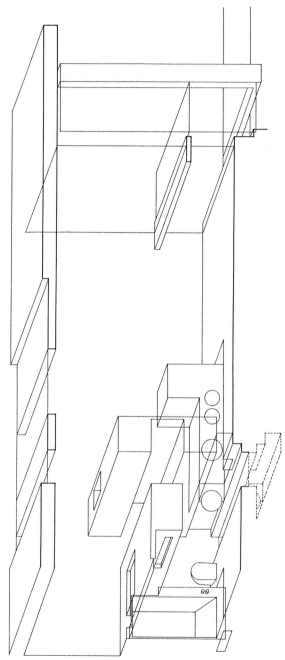

MULTIPLE CONFIGURATIONS

Dressing/en Suite

Guest Bedroom

Winter

Summer

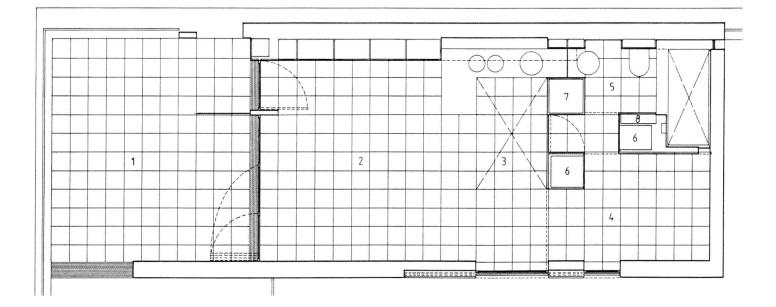

1. Terrace
2. Living Area
3. Kitchen
4. Bedroom
5. Bathroom
6. Wardrobe
7. Laundry
8. Towel Recess

Below Left: Detail of the bathtub.

Below Right: Detail of glass canopy over the terrace.

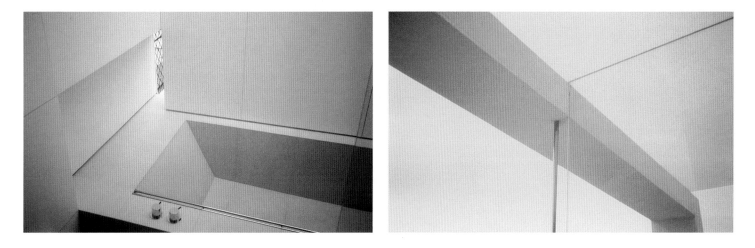

LIVE/WORK DUALITIES

Dean/Wolf Architects

The architects designed this small loft to serve as both their office and home. The dining room with its heavy concrete table is in the center of the loft and serves as the primary space for most activities. Adjacent to the office area, it functions as a conference room by day. At other times, it serves as an entertaining space for dining. The table is anchored spatially by five lighting fixtures suspended from cords that slide over to the entry wall behind the table. The ceilings are quite high, allowing for a guest sleeping loft to be created above the bathroom. It is accessible by a multipurpose canvas and steel "ladder door."

Right: The apartment centers around the dining room, which is the primary space of all interaction: entertaining, meetings, and dining. The massive concrete table is anchored spatially by the light cords, which slide over to the entry wall. The tall split-back chairs reference human height.

Photography: Eduard Hueber

BIG IDEA: "Live/Work Dualities" is the kind of loft that only happens in a city where space is precious and expensive. To maximize the use of the very limited square footage in this fifth-floor walkup, the architects created a series of screens which allow dual functions to inhabit the same space. Each screen either makes use of movable elements or view connections to expand both the real and perceived spatial dimensions of the apartment.

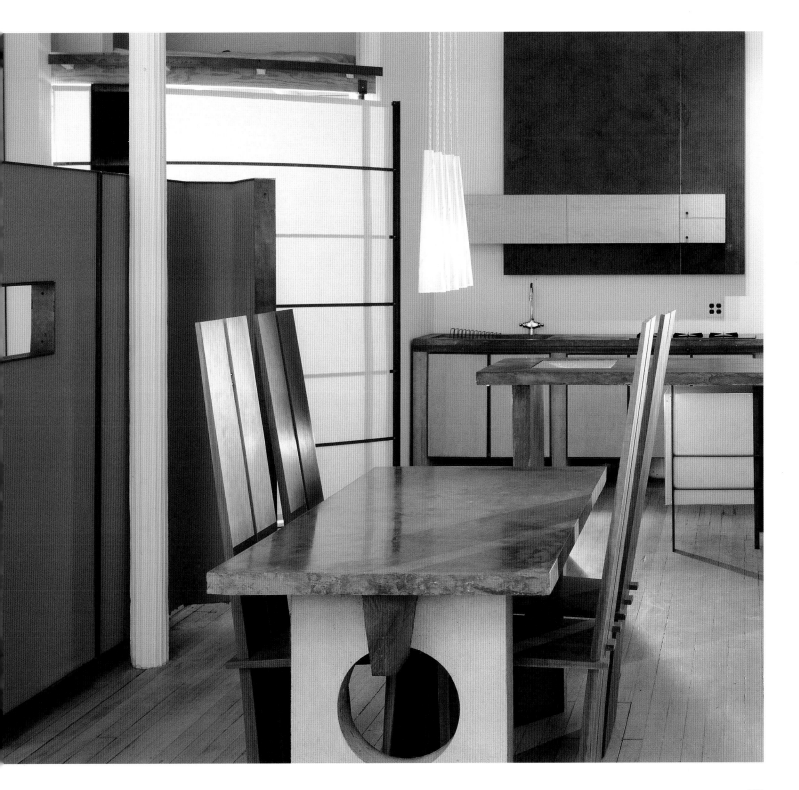

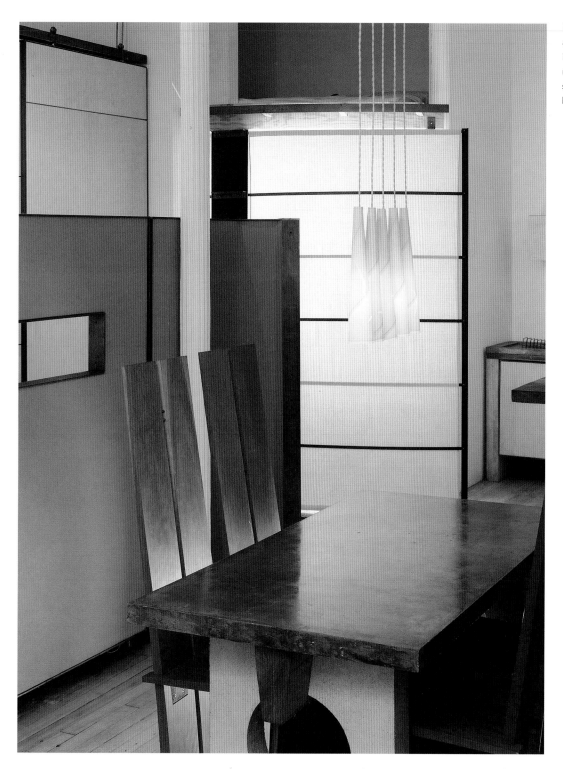

Left: Behind the dining table is a fabric and steel screen wall separating the dining area from the office. It visually connects the dining area to the office space. At the far end is the kitchen and bath.

FLOOR PLAN

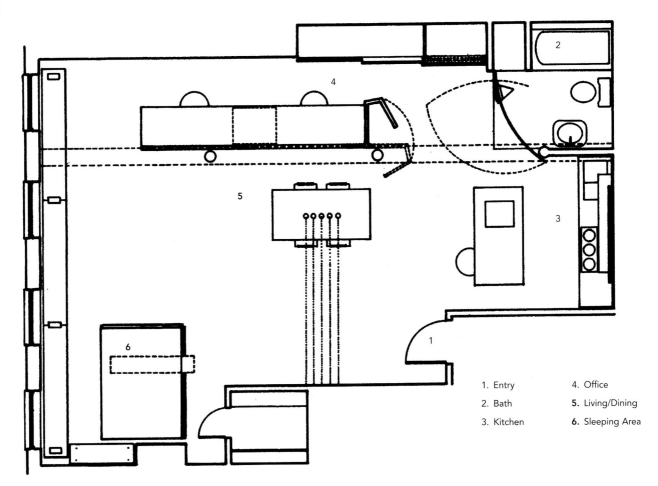

4

5

6

1

2

3

1. Entry
2. Bath
3. Kitchen

4. Office
5. Living/Dining
6. Sleeping Area

SECTION

AXONOMETRIC

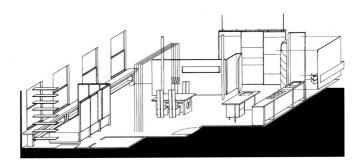

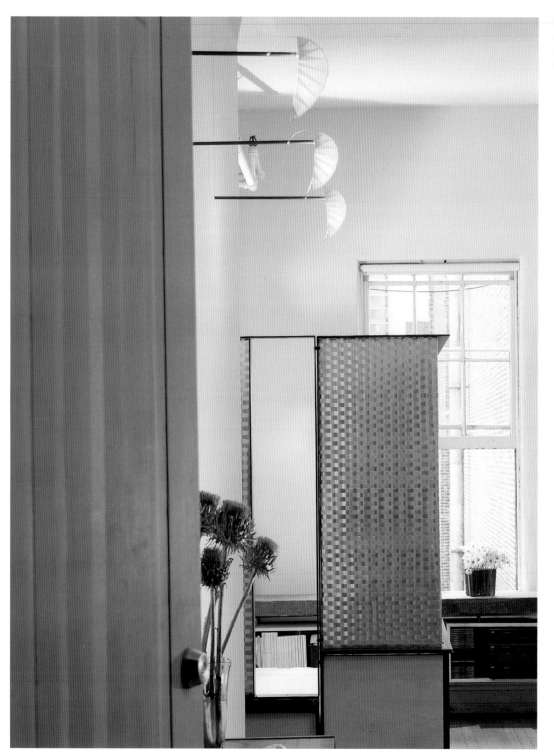

Left and Right: A woven metal screen separates the bedroom from the living space. A shelf inserted into the screen (right) allows for breakfast in bed.

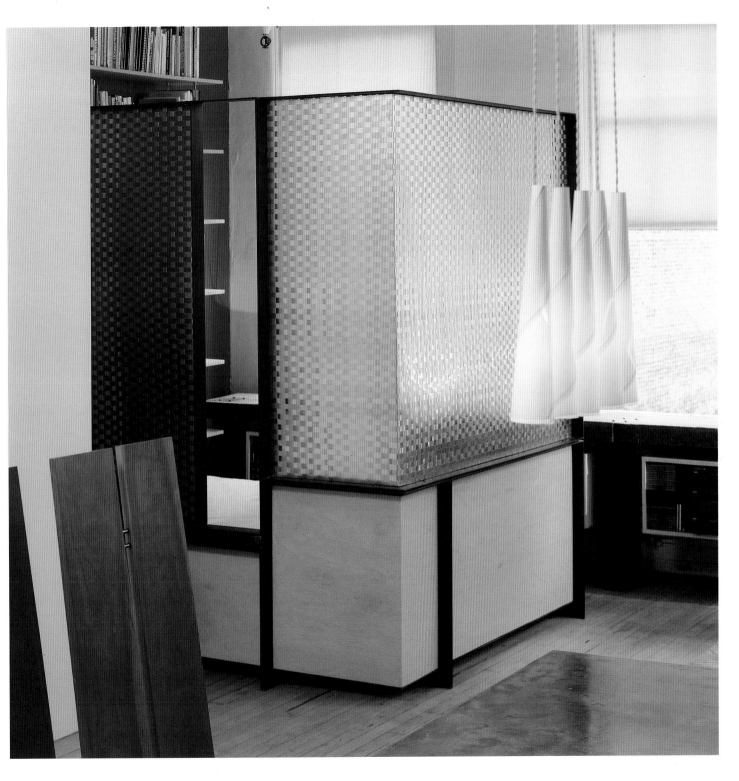

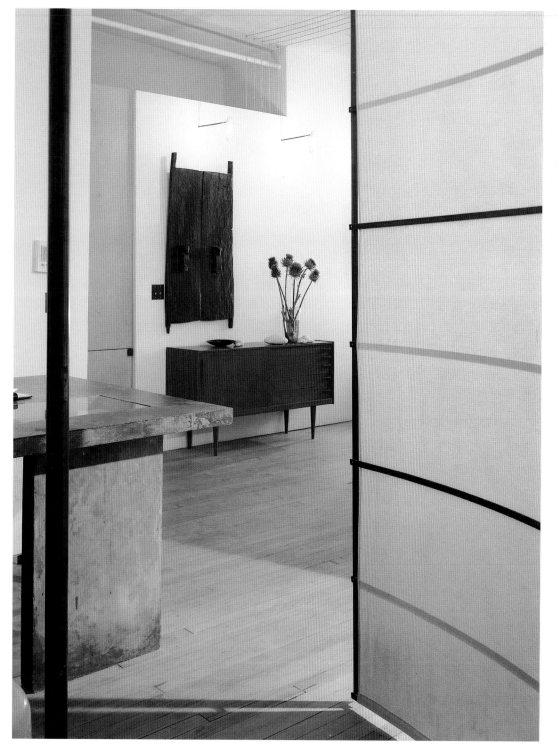

Left and Right: The most flexible screen in the apartment is the canvas and steel "ladder door." The steel frame acts as a ladder, giving access to the guest room loft above the bath. Beneath the screen is a ball bearing pivot which allows the screen to completely open, joining the bath to the rest of the space. The canvas enclosure brings light in during the day and glows at night when the bathroom light is on.

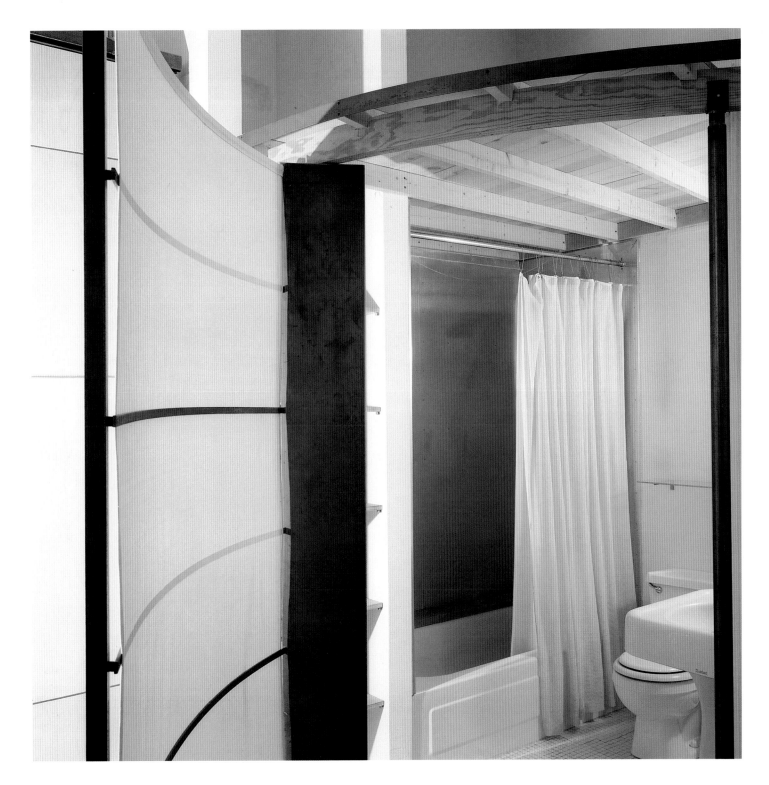

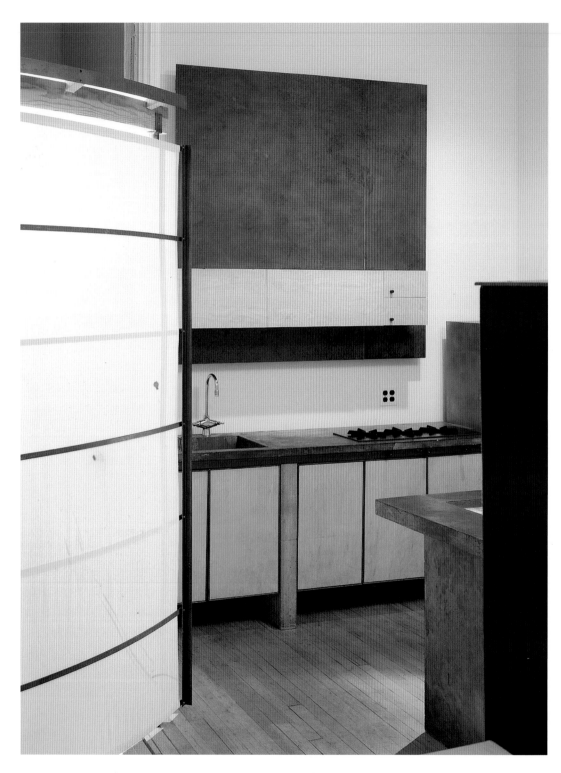

Left: The kitchen anchors the apartment at the back in a field of color. The counter and sink are made of concrete.

Right: The visual slot of the bed screen creates an intimate view back into the apartment.

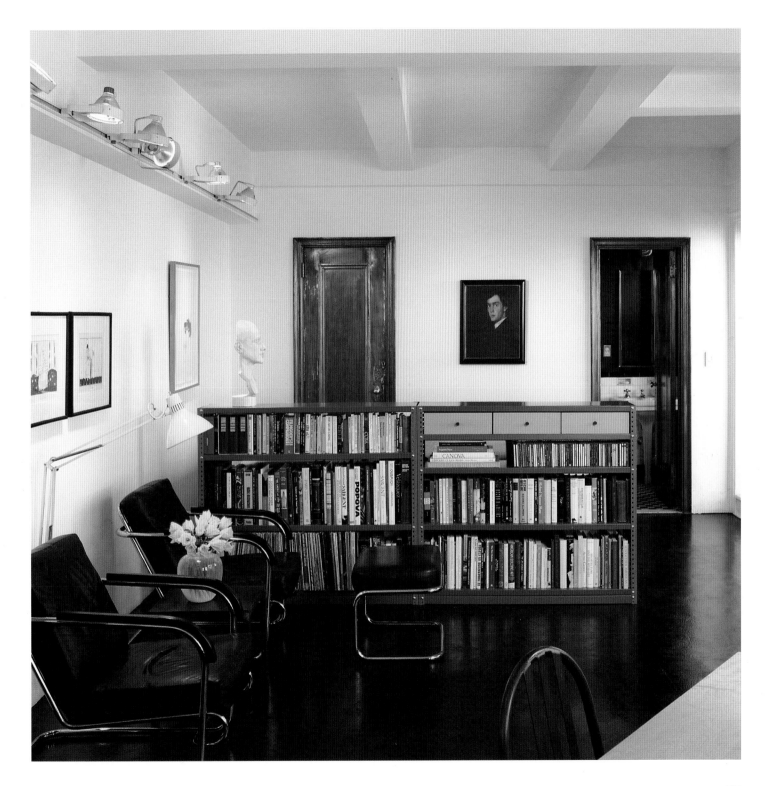

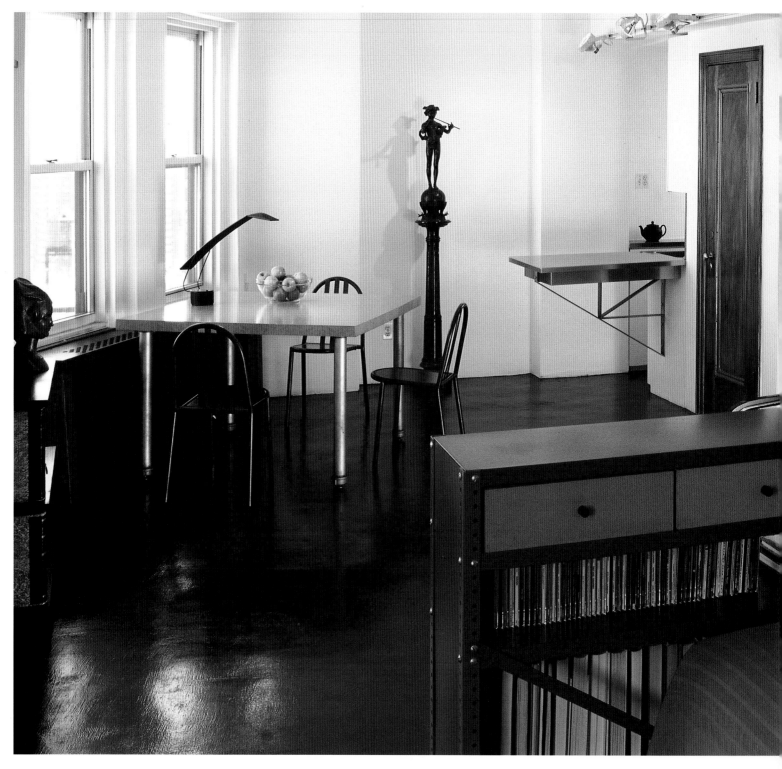

Left: In the sleeping area, the space divider is assembled from standard industrial shelving and fitted with cus-tom-fabricated drawers. The dining table (left) is made of birds-eye maple and galvanized pipe. The plaster bust to the right is by the architect, who is also an accomplished portrait sculptor.

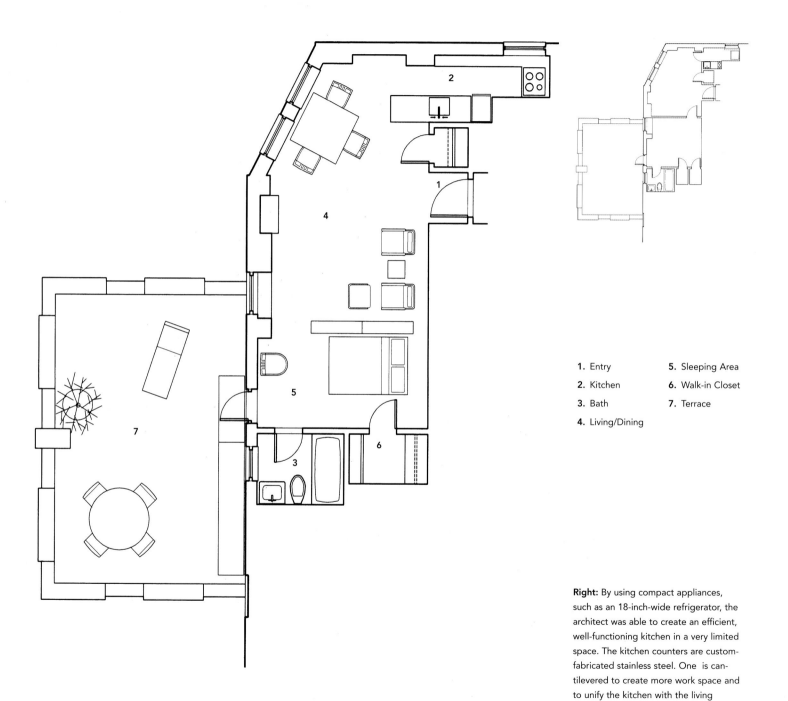

1. Entry **5.** Sleeping Area

2. Kitchen **6.** Walk-in Closet

3. Bath **7.** Terrace

4. Living/Dining

Right: By using compact appliances, such as an 18-inch-wide refrigerator, the architect was able to create an efficient, well-functioning kitchen in a very limited space. The kitchen counters are custom-fabricated stainless steel. One is cantilevered to create more work space and to unify the kitchen with the living space.

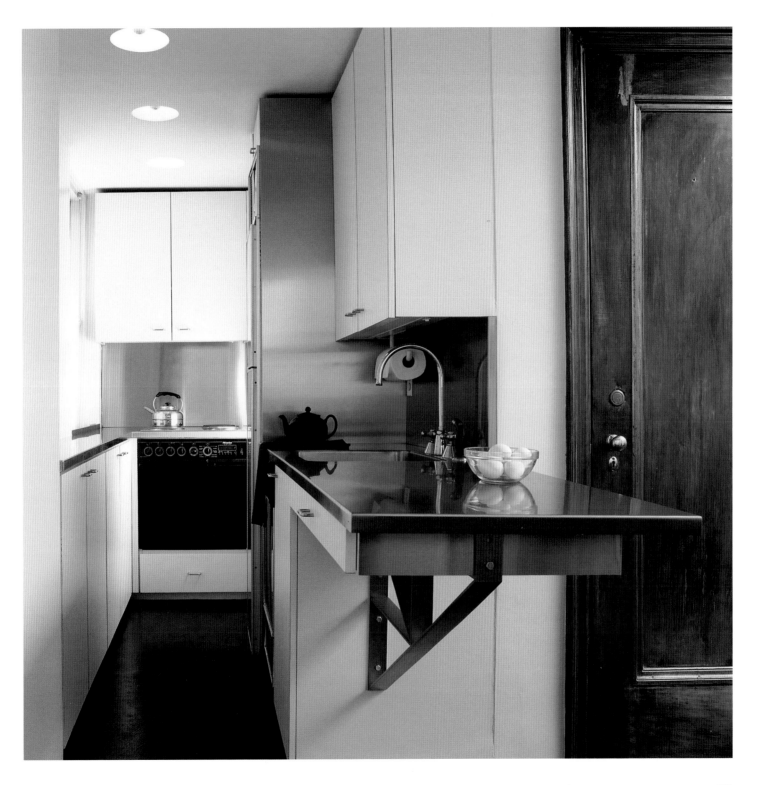

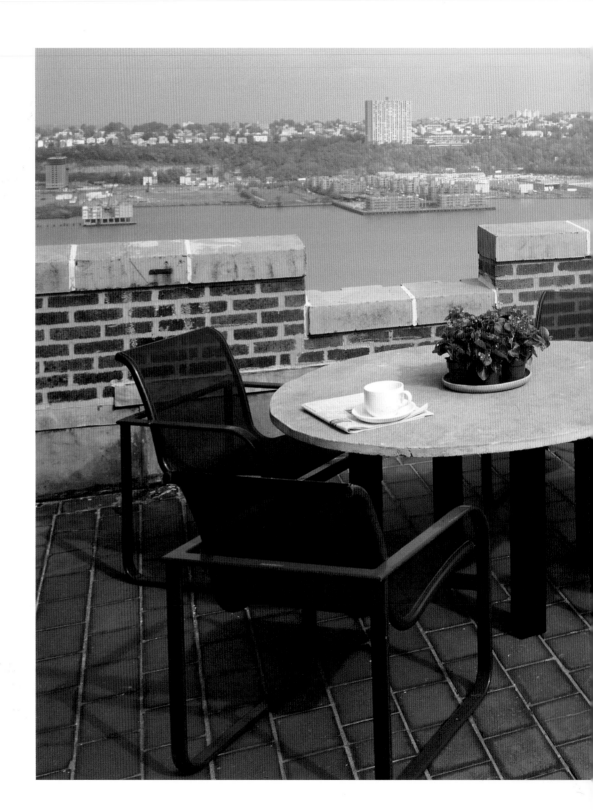

Right: The terrace is nearly equal in size to the apartment, dramatically expanding the living space in warm weather.

DESIGN DIRECTORY

Mark Guard
Mark Guard LTD. Architects
London, England

Frederick Biehle
Erika Hinrichs
Via Architecture Studio
New York, NY

Leo Blackman
Buttrick White & Burtis
Architecture
New York, NY

James Brehm
New York, NY

Anita Cooney
Anthony Caradonna
AC2
New York, NY

Manuel Fernandez-Casteleiro
Parson +Fernandez-Casteleiro, PC
New York, NY

Belmont Freeman
Belmont Freeman Architects
New York, NY

William Green
William Green and Associates
New York, NY

Thomas Hanrahan
Victoria Myers
Hanrahan & Myers Architects
New York, NY

Scott Specht & Louise Harpman
Specht Harpman Design
New York, NY

Ken Kennedy
Ken Kennedy Architect
New York, NY

Richard Lavenstein
Bond Street Architecture Design
New York, NY

Diane Lewis
Diane Lewis Architect
New York, NY

Hiroshi Naito
Naito Architect & Associates
Tokyo, Japan

Robin Elmslie Osler
EOA / Elmslie Osler Architects
New York, NY

Marco Pasanella
The Pasanella Company
New York, NY

Martine Seccull
Martine Seccull Architect
Prahran, Australia

Peter Stamberg
Paul Aferiat
Stamberg Aferiat Architecture
New York, NY

Diana Vinoly
Diana Vinoly Interiors
New York, NY

Kathryn Dean
Charles Wolf
Dean / Wolf Architects
New York, NY